Daylight

Ex Crucible

The Passion of Incarcerated Artists

Peter Merts

Cofounders: Taj Forer and Michael Itkoff
Creative Director: Ursula Damm
Copy Editor: Gabrielle Fastman

ISBN: 978-1-954119-12-3

Printed by Ofset Yapimevi, Turkey

Daylight Books
E-mail: info@daylightbooks.org
Web: www.daylightbooks.org

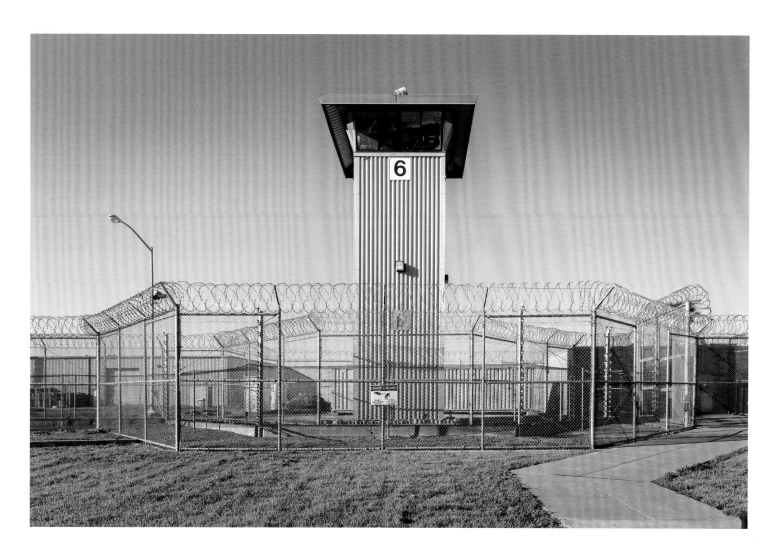

Gun tower
Solano State Prison, 2015

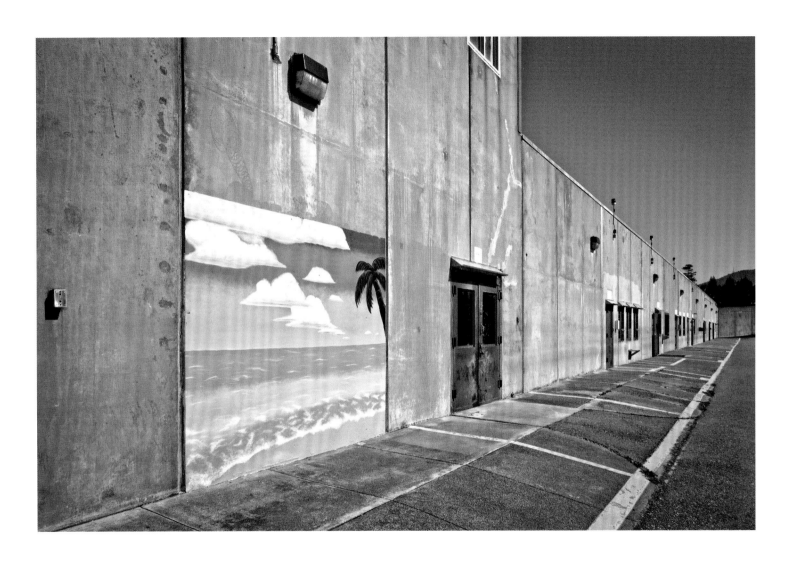

Mural on an exercise yard
Pelican Bay State Prison, 2016

Dedicated to all the artists
in California state prisons —

those who teach,
and those who learn.

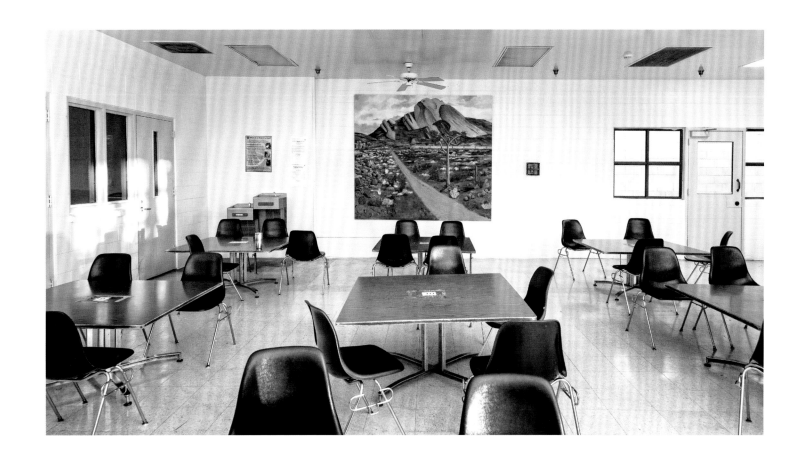

Visiting room with painting
RJ Donovan State Prison, 2014

Introduction

—Peter Merts

The first time I entered a penal facility, I stayed for ten days. That was in San Luis Obispo, California, in the late '70s—a consequence of civil disobedience enjoined by me and several hundred others at the newly constructed nuclear power plant there on the San Andreas Fault. Around that same time, I went to work for Mimi Fariña at Bread & Roses (now Bread & Roses Presents), a nonprofit (NGO) in the San Francisco Bay Area that produces free entertainment in all manner of institutions, from children's hospitals to jails and prisons.

While at Bread & Roses I helped produce a few concerts on the yard at San Quentin State Prison and joined a bus tour that featured two bands performing at several prisons in Northern California. While producing institutional concerts for this nonprofit I witnessed remarkable, heartwarming exchanges between volunteer performers and the institutional residents—scenes of generous artistry and profound appreciation. I thought to myself, Someone should be documenting this! That is how I became a photographer.

For the several decades since working at Bread & Roses I have continued to photograph their programs as a volunteer. When that organization teamed up with the William James Association, a provider of arts instruction at San Quentin State Prison, to produce a series of instructional music workshops for the inmates, I documented the sessions. Classes were taught by professional musicians and included blues slide guitar, jazz guitar, improvisational singing, songwriting, and blues harmonica.

Project Inception

One day Steve Emrick, the manager of San Quentin's art classes, invited me to document some of the prison's other, non-musical, art classes. I was intrigued of course by the incongruity of artistic expression in such a regulated, disruptive, and sometimes violent environment, and I recognized the rarity of the opportunity. I also felt an empathy for incarcerated men and women, many of whom, like me, had experienced childhood trauma. Beyond these factors, it just felt like a great concept—art as a response to damaged lives.

Over a fifteen-year period I photographed prison art classes in all of California's thirty-six adult state prisons. The images have appeared in a variety of media to document and promote these art classes. One such effort resulted in the book *Paths of Discovery: Art Practice and Its Impact in California Prisons* (second edition published in 2015) by Dr. Larry Brewster and me, covering California's Arts in Corrections program. It also contains interviews, artwork, creative writing, historical context, and the research findings of Dr. Brewster and others.

Artistic Passion

This current book is something different; it is an experiment to see if the huge photographic archive I have amassed for this project can be distilled down to some essence—to a meaningful truth about prison art classes. Upon reviewing this archive, I

was reminded of some things that most impressed me about these classes. I recalled the amazing commitment of the students—the willingness to participate wholeheartedly, even when vulnerability or silliness was required. I remembered men and women exploring emotional territory and expressing themselves with authenticity and vitality. I repeatedly saw students collaborating and mentoring, even across racial divides that were inviolable on the prison yard. I saw amazing performances and deeply felt, skillfully crafted art products, covering topics such as identity, race, family, culture, and social justice. There was joy, pain, frustration, and growth as the men and women developed conceptual maturity and technical mastery. I began to think of these men and women not as art students but as artists.

How to encapsulate this constellation of attitudes and qualities? I think of them as manifestations of artistic passion—of creative explorations and expressions characterized by care, dedication, talent, and fervor.

What to make of this book's main title, *Ex Crucible*? It refers to an immutable stone container—in this case, a prison—as a place where intense energy refines and purifies a precious substance. The energy I'm thinking of is the experience of trauma and incarceration; the precious substance is artistic passion.

Arts in Corrections

Most classes I visited are part of Arts in Corrections, a state-wide program funded by the California Department of Corrections and Rehabilitation and administered by the California Arts Council (CAC). I share my images with these organizations, who use them to promote their programming.

For a fifteen-month period I photographed under contract with the CAC; those photos appear here courtesy of the California Arts Council.

Studies have demonstrated the effectiveness of art practice in modifying the attitudes and behaviors of incarcerated men and women—the development of confidence, self-control, and self-awareness; the reduction of disciplinary infractions; and the improvement of relationships with other inmates, staff, and family. Yet public sentiment regarding prison arts programming remains tepid at best. This situation has led me to my greatest aspiration for this work: to illuminate the *humanity* of these incarcerated men and women, who are working so passionately to express themselves, to recover from their traumas, and to lead more fulfilling lives.

Prison Towns

To make these photos I traveled to all of California's adult state prisons, which are spread from one end of the state to the other. I sometimes overnighted near a prison, or arrived to the area hours before I was due to go inside. I took these opportunities to explore a bit of the area around the institution—just driving the local roads or stopping in a cafe for a meal.

Most of California's prisons are far from population centers; they are out in a desert, or surrounded by vast farmlands, or tucked into a forest. There is often a small town near the prison—a retirement community, a farm village, an old lumber town. I made some photos of those prison towns and present them here. I think of these photos as referring not only to my own experience in pursuit of this photography project, but also

to the experiences of the families of the incarcerated, who often travel many miles to pass through these same spaces on their way to visit a loved one inside. Finally, these images made outside the walls stand in counterpoint and as a reminder—that all the other images in this book were made *inside* the walls.

—Peter Merts
October 2021
www.petermerts.com

NOTES:

I sometimes refer to a prison by its colloquial name rather than the official one. For example, I use *Lancaster State Prison* rather than *California State Prison Los Angeles County*.

The pandemic of 2020 suddenly halted all prison programming, including in-person art classes. Instructors resorted to the US Postal Service as they transformed their classes into correspondence courses. As of this writing, in-person art classes have resumed in some California prisons, with occasional interruptions as new COVID-19 outbreaks occur.

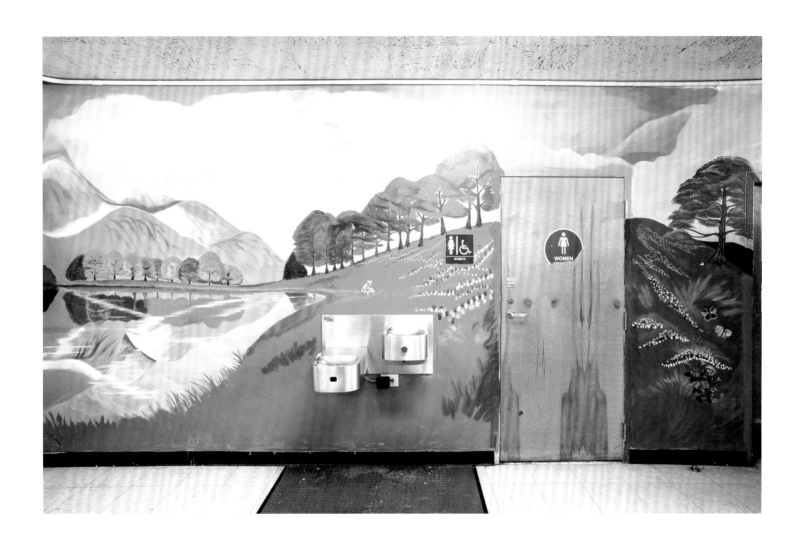

Visiting room with mural
California Institution for Men, 2010

Peter Merts: The Persistent Kindness of Looking

—Annie Buckley

A man stands alone in a dark room, the light from a single window hitting the back of his shaved head and casting a shadow in front of him. In one outstretched hand, he holds an upright sheet of white paper graced with a blue monochrome painting illuminated by the light. It depicts a single tree in an amorphous landscape, its trunk curving elegantly through the center of the composition. *Oil Painting, Pleasant Valley State Prison*, 2019 (page 25), is one of thousands of photographs in an expansive body of work by Peter Merts that generously shares the unique experience of creative arts in prisons with both the families of the artists and the world at large. In fact, in the California prisons where Merts takes the vast majority of his images (and where I also run a prison arts program), the men and women who are incarcerated literally wear the label of Prisoner on their backs, in yellow letters on blue shirts. It is interesting that the man holding the image of the tree looks strikingly similar to Merts himself—a reminder of how thin the line between us actually is, despite the fact that society continuously reifies this distance. Merts's portfolio silently and insistently debunks such separation, knitting us together in creativity.

In this time of great social reckoning, when more and more people recognize the deep impacts of structural racism, economic injustice, and mass incarceration, Merts's body of work is both spotlight and lightning rod. His illuminating focus and dedication to making deeply personal and graciously compassionate images—of a creative practice that most people will never see or participate in—provides a window into a particular aspect of the prison experience. As more and more people rightly argue for a critical analysis of the intricate connections between capitalism, systemic injustices, income disparity, and the prison-industrial complex—including calls to end practices such as solitary confinement and youth imprisonment—some may question how it is helpful to see these bright images of joy from inside prison. Merts's work responds with a refreshingly clear-eyed and collaborative vision, by demonstrating what happens when the most forgotten and isolated among us have the opportunity to find and use their often lost or neglected voices, through the arts. The astounding array of human experience on view in Merts's images—joy, love, laughter, community, concentration, grief, anger, loneliness, creativity, curiosity—testifies to our shared humanity and interconnections in ways that words cannot. It is a vital part of the dialogue about how we can evolve as a society, both in our thinking about imprisonment as well as in expanding access to the tremendous impact of the arts. Merts's work does more than show art in action; it shows the

near holy importance of a moment of freedom and community within a place of long-term isolation and captivity. The vitality and purposefulness of the movements of three men at the center of *Hip-hop dance, Ironwood State Prison*, 2016 (page 59), are arguably not just similar to a group of men dancing at a concert but actually a larger-than-life exaggeration of street dance. The expressions on the faces of the men in *Theater, California Health Care Facility*, 2018 (page 75), embody emotions—contentment, joy, questioning, and tenderness, respectively—writ large.

I think this speaks to the poignancy of arts programs in prisons. An art class in a university or community setting can be a haven for students to grow and thrive; inside a prison, it is a living and breathing oasis from confinement. Participants in these classes are often in collaboration with people they don't interact with outside class, and with whom interaction might in fact be dangerous. Yet in the art classes, together with teachers from outside the prison, they communicate freely and warmly with the shared reward of experiencing the sense of freedom, expression, and expansion that the arts invite.

Yet the razor's edge between the liberatory space of a prison art class and the confining space of prison life is as brief and tenuous as it is positive. Most classes last about three hours— only a portion of a long day—and their continuation is critically dependent on a shared commitment to rules both written and unwritten. A seemingly minor incident—a paintbrush gone missing, an incarcerated student standing too close to a teaching artist—and the whole thing comes crashing down. Outcomes can be drastic. Students might be sent back to cells to endure a comprehensive search or even a lockdown. Individual incarcerated students might be asked not to return to the program. And

sometimes an entire program is banned from the prison. Such outcomes are rare, but everyone is aware of their possibility. Those who come into an art room know that the sanctity of the space must be collectively upheld. This tension—the high stakes, the brevity—begins to explain the exaggerated sense of focus, being, and engagement of the individuals depicted throughout Merts's photographs.

In such a fraught environment, care and thoughtfulness are integral to the process, and Merts is welcomed in to document these moments of vulnerability because of his personality and approach. The exacting steps behind his seemingly effortless photographs—of men embracing, women leaping, students laughing, painted faces engaging in theater—begin long before Merts arrives at the prison. He engages in weeks of dialogue with partners in corrections, arts organizations, and state agencies in order to gain approval and plan his visit. Once there, he takes a generous amount of time at the beginning of each session to explain the process to the men and women that he will photograph. He is clear but detailed, sharing the purpose as well as such details as how close he might stand, the pops of his flashes, and how to signal if his presence is interrupting the art process.

It should be noted that everyone who appears in his images has agreed to be photographed and understands that the images will be shared publicly. For most, the draw of being seen might be sufficient motive for consent, but the added benefit of Merts making all his images available for free online is an immeasurable gift to those with little to no other way to share these images with loved ones outside. Merts is a kind and gentle presence and a consummate professional—detail

oriented, diligent, and observant, yet also ready to laugh at himself, join the fun, and smile. He is perhaps the most humble person I have ever met and for all these reasons the men and women in the prisons universally, as far as I have witnessed, respect and love him.

The context of prison is a ubiquitous if quiet element throughout Merts's photographs, adding layers of meaning and emotion. In some, incongruously small windows placed uncommonly high on concrete walls seem to float in the background. In others, faces smiling or covered in theatrical masks are seen through glass crosshatched with metal. Basketball hoops rise behind people engaged in full-throated song or mid-stride in the graceful rhythm of African dance. Even when the physical space of the prison is not visible, its omnipresence adds layers of context. Students gaze in earnest attention at guitars; a tattooed hand hovers over a piano; heads bow and hands reach over one another to create a carving, or a mandala. Throughout these images, viewers—like the students themselves—are temporarily suspended in a glow of creativity, aware of but suppressing the razor wire, at once literal and metaphorical, just out of frame. In *Modern dance, Central California Women's Facility*, 2017 (page 69), a woman is seen in midair, a white tutu floating like clouds around outstretched legs, her face an embodiment of bliss. Instead of a stage, she dances on a concrete floor, a pair of vending machines the only set.

The heaviness of these industrial and confining spaces draws a sharp line around the vivid joy in the images, adding context and meaning to every photograph. In *Movement and spoken word, San Quentin State Prison*, 2015 (page 61), one man gently holds another as he falls, their elegant posture reminiscent of a Rodin sculpture and a Shakespeare play. In this context, the photograph takes on the pathos of imagined pasts and futures—death on the streets, what brought these men to this space, the tragic way their lives might have, or might still, end—and, at the same time, illuminates the tenderness of shared space, reconciliation, and understanding. *Theater, California Institution for Women*, 2019 (page 74), features four women of diverse ethnicities standing in postures that mime the cradling of a baby, the holding of a toddler's hand, and the caress of a pregnant belly. The expression of a woman with her arms around an absent child is so sweet that it takes a moment to digest the impact of this image, suggesting the depths of loss for mothers locked inside as their children grow up without them.

In *Theater, California Medical Facility*, 2018 (page 76), a Black man lies supine while a White woman confers with two other men, notepads in hand and pencils poised. Their seeming indifference to the recumbent man is jarring. Though they are in fact engaged in a creative process, this powerful image suggests individual and communal loss, the tragedy of the distance between us, and our societal and personal capacity to ignore or not see the pain of others. Is this man a dream, a hallucination of our collective unconscious? Is he dead, asleep, or just unseen?

Among Merts's photographs is a distinct and separate group featuring the small towns in and around California state prisons. The vast majority of these images are strikingly absent of people—a roadside sign reading "Open" is poised beneath an empty frame, stripped of any signage, in a green field absent of inhabitants in *Orick, on the way to Pelican Bay State Prison*, 2016 (page 6[PT]), and a field of transmission towers stretches into the distance beyond a vast and empty highway in *Blythe, near Ironwood and Cuckawalla Valley state prisons*, 2016 (page 9[PT]). These images are in stark contrast to the vibrant and lively energy of

the people in the arts classes. At the same time, the glamorous natural beauty on view—a field of orange poppies in *Antelope Valley, near Lancaster State Prison*, 2019 (page 16[PT]); the brilliant ray of light through an expansive dark sky in *Susanville, near High Desert State Prison and California Correctional Center*, 2016 (page 3[PT])—are quiet reminders of what those inside lack. That carefully painted blue tree curving on the page, lit by a single ray of light, is a painstaking effort to recreate what is lost.

ABOUT THE AUTHOR:

Annie Buckley is a multidisciplinary artist, writer, and educator working at the intersections of art and social justice. She is the founder and director of Prison Arts Collective (PAC), a collaborative project dedicated to expanding access to the transformative power of the arts to people experiencing incarceration in California.

She has written for numerous publications, including *Artforum*, *Art in America*, the *Huffington Post*, and *KCET Artbound*, and is a contributing editor to the *Los Angeles Review of Books*.

Buckley is a professor in the School of Art + Design and director of the Institute for the Arts, Humanities, and Social Justice at San Diego State University.

www.prisonartscollective.com
www.anniebuckley.com

California State Prisons

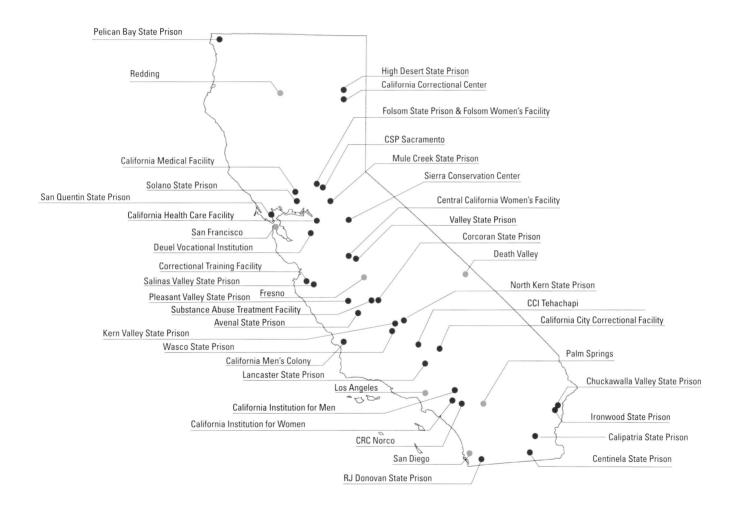

Pelican Bay State Prison

Redding

High Desert State Prison

California Correctional Center

Folsom State Prison & Folsom Women's Facility

CSP Sacramento

Mule Creek State Prison

California Medical Facility

Sierra Conservation Center

Solano State Prison

Central California Women's Facility

San Quentin State Prison

California Health Care Facility

Valley State Prison

San Francisco

Corcoran State Prison

Deuel Vocational Institution

Death Valley

Correctional Training Facility

Salinas Valley State Prison

North Kern State Prison

Pleasant Valley State Prison

Fresno

Substance Abuse Treatment Facility

CCI Tehachapi

Avenal State Prison

California City Correctional Facility

Kern Valley State Prison

Wasco State Prison

California Men's Colony

Palm Springs

Lancaster State Prison

Los Angeles

Chuckawalla Valley State Prison

California Institution for Men

California Institution for Women

Ironwood State Prison

CRC Norco

Calipatria State Prison

San Diego

Centinela State Prison

RJ Donovan State Prison

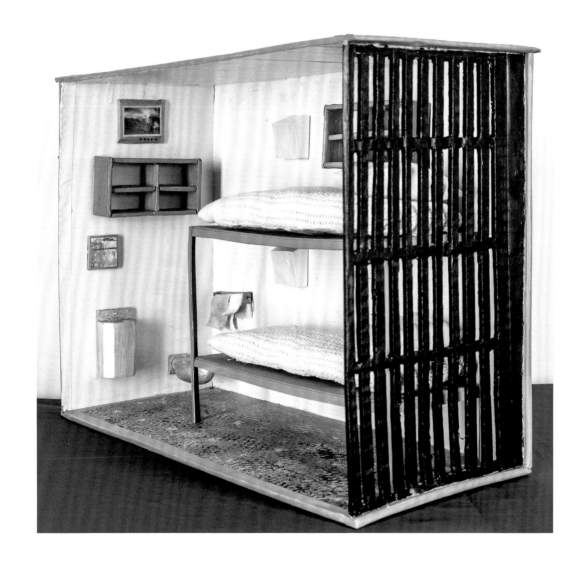

The Cell, by Roy Gilstrap and Gary Harrell; cardboard, acrylic, cloth, clay;
12 x 17 x 6.5 in. (courtesy of the William James Association)

Mug Shots

By Rahsaan "New York" Thomas

Mug shot. My hair, matted curls. Rage frozen in my eyes, just above a scowl. The worst look, taken on an even worse day.

The *New York Daily News* ran that image in its Most Wanted section three times from 1998 to 1999. My last impression left on New York City was the mad look of a "violent felon."

Someone invented Google after a court sentenced me to fifty-five years to life in 2003. Typing my name in would bring that picture back from some computer archive. That's the picture my sons would see when old enough and curious enough to Google.

Determined to find a way for my sons and mother to be proud of me regardless of my circumstances, I came up with the idea of being a writer. I had never written before, but I envisioned authoring a book about my life that kids from my neighborhood would read and drop their guns. I wrote and wrote, without a mentor, without training, without knowing what I was doing or what kind of help to even ask of my family.

Finally, in 2013, my custody level dropped and I found myself at San Quentin, a progressive California state prison that has several writing programs. I signed up for the William James Association's creative writing class taught by Zoe Mullery. Every week she gave out writing prompts. From one, I wrote *One Bad Apple*, a fictional account of the real gun violence I experienced at seventeen years old that set me on the path of armed confrontations.

One day Zoe announced that we had seventy-five members of the public coming in to hear us read for five minutes each. I chose an excerpt from *One Bad Apple* for my selection and practiced to read it for the first time to an audience of community members.

On the day of the event, Peter Merts came in ninety minutes early to take portraits of everyone in the class, about twenty of us in all. When my turn came, I posed with the biggest, brightest smile. We took several solo pics and a class photo, plus Peter photographed us as we stood at a podium reading our stories to the community.

I fought back tears as I read *One Bad Apple*, pouring out the day I fled as an armed robber shot my little brother.

When I was finished I avoided looking at the audience, fearing judgment. The crowd applauded. At the break, two ladies

walked up and asked for my autograph. I smiled, feeling relieved that I had been heard and appreciated.

Peter captured me at the podium, freezing the happiness I felt on one of my best days in prison. That snapshot also showed the new person emerging from a dark past.

Peter photographs the creative writing class every time we have a public reading, and his pictures are the best ever taken of me. I use them often in articles and bios for my freelance writing career, which includes stories for the Marshall Project, NBC Universal Academy, *Business Insider*, *Current*, and many others.

Peter's pictures show incarcerated people as they are today, post-traumatic influences, and give us an opportunity to be seen as much more than "violent felons." Now, when my sons type their dad's name into Google, pictures come up with me wearing a big, bright smile, accompanying the positive accomplishments reframing my past.

Thank you, Peter Merts.

ABOUT THE AUTHOR:

Rahsaan "New York" Thomas cohosts and coproduces the hit podcast *Ear Hustle*, which was nominated for a Pulitzer Prize and won a Dupont Award in 2020. He's also a contributing writer for the Marshall Project, *Current*, and the *San Quentin News*.

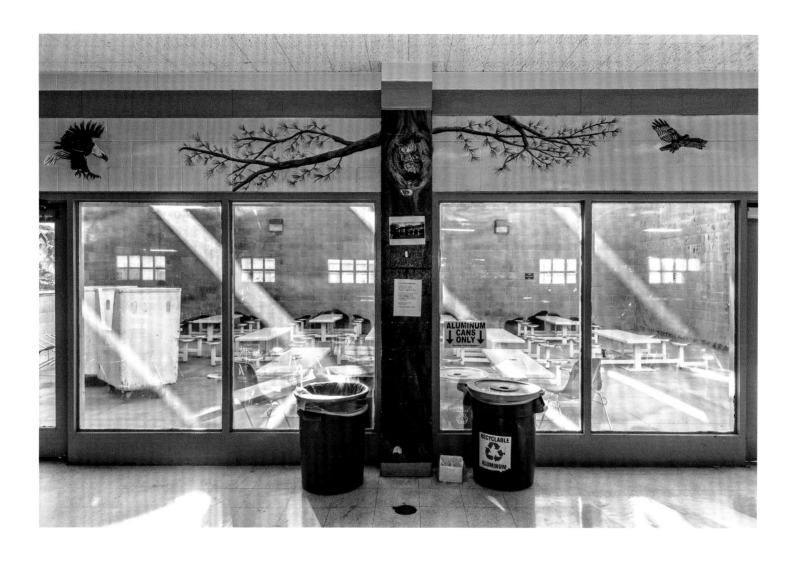

Visiting room with mural
Solano State Prison 2015

Peter Merts:
Artful Photojournalist Behind the Wall

—Kevin D. Sawyer

I'd never heard of Arts in Corrections, much less Peter Merts, until I arrived at San Quentin in 2011, about fifteen years into my sentence of forty-eight years to life. The extent of my time as an "artist" had been disbursed in a cell, inside several prisons where I read, wrote my thoughts, sketched, and played my guitar. People had always told me I was creative because those activities came naturally.

During the early years of my now twenty-five years of incarceration, I centered the majority of my time on the study of law and reading books. By the time I arrived at San Quentin I'd read exactly 295 books on a variety of subjects, and I had written a mixture of more than two dozen stories, essays, and poems. When I wasn't noodling around on my guitar, I studied music theory. Still, there was no creative outlet for all the energy I'd generated from within.

The William James Association created time and space for me to work, and it opened a passage for my efforts to escape from inside of me and be released to the world. One day, in the fall of 2012, some guy showed up with a camera to photograph the creative writing workshop that I've attended for close to a decade. It was at one of the program's annual public readings, where an audience from outside enters the prison to attend a literary reading of our work.

That guy, that professional photographer, I soon learned was an artist himself. Through his lens, Peter Merts captured the first images of me standing in the interior of the 169-year-old castle-like San Quentin, with its battlements in full view behind me. These were the first photographs taken of me in prison, outside of the many Polaroid photos that were offered in different institutional visiting rooms. I thought the photo shoot would be a one-off. I was astonished to see my image in the foreground and California's oldest prison in the background. There I was in contemplation of all I'd been through, my fate still indefinite. Little did I know Peter would return to the prison, again and again.

That was nearly a decade ago, and since then Peter has photographed me at several creative-writing events. "You're very photogenic," he once said to me. As an artist, whether reading or performing on a stage, I'm aware of a photographer's presence and camera. For that reason, I try to stay ready. But

there was one time he showed up, unannounced, at a guitar workshop I attend. He took photos of the group the day after a two-week lockdown, as I recall. To say I wasn't prepared would be a gross understatement. I didn't want my picture taken because I looked disheveled, needed a shave and haircut.

A good photographer takes good pictures. But a great photographer makes a subject feel comfortable under less-than-ideal circumstances. Peter captured my dedication to an artful undertaking when I was unprepared. In the spur of the moment, the lightness of contrast of a bad day—instead of a more preferable instant—passed through a lens when a shutter opened. Photogenic or not, we all have off days. The camera doesn't care, and neither does the shutterbug. Simply because art isn't perfect, especially in a place where men are sent because of their imperfections. Peter and his camera delineate factual moments for his subject and observers to transcend time.

The William James Association, other volunteers from communities outside, and an untold number of unsung heroes redeem those of us who've been disappeared. They make use of unique conventions to help men heal. Artists helping artists. Peter's method reflects and refracts light to accomplish this objective, and we're all better because he came here, saw us, and placed in good hands our images.

ABOUT THE AUTHOR:

Kevin D. Sawyer is the associate editor for the *San Quentin News* and a member of the Society of Professional Journalists (SPJ). He has written numerous short stories, memoirs, essays, poems, and journals, and has been published in the *San Francisco Chronicle*, *Oakland Post*, *UCLA Law Review*, *The Guardian*, *Columbia Journalism Review*, *Prison Journalism Project*, *Journal of Prisoners on Prisons*, *Harvard Journal of African American Policy*, and many other places. He was a 2019 PEN America Honorable Mention in nonfiction, a 2016 recipient of the James Aronson Award for community journalism, and part of the *San Quentin News* team that won SPJ's 2014 James Madison Freedom of Information Award.

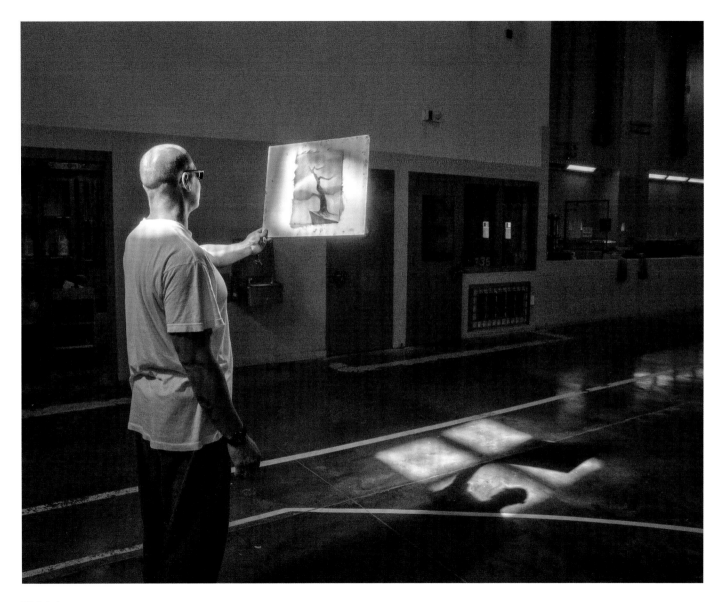

Oil Painting
Pleasant Valley State Prison, 2019

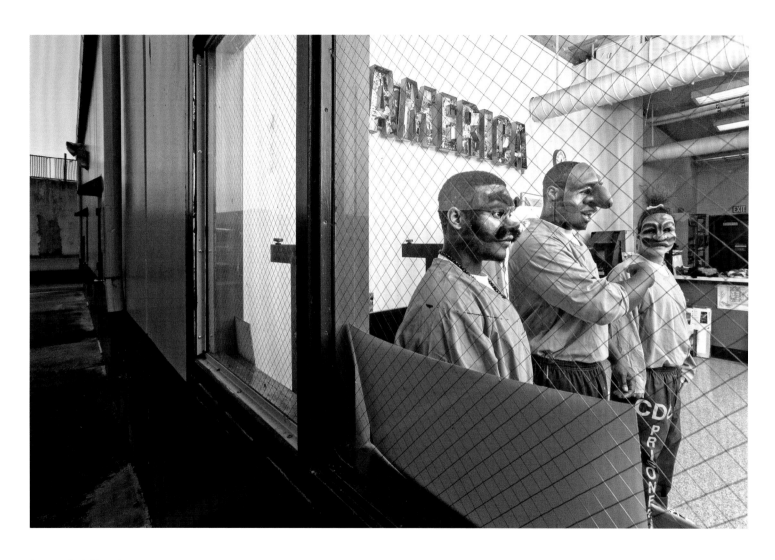

Commedia dell'arte theater
Pelican Bay State Prison, 2016

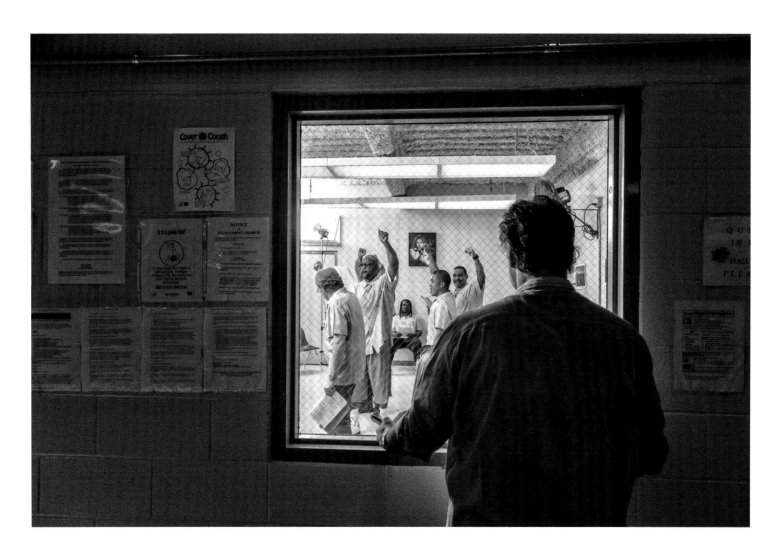

Rehearsal of Shakespeare's *Macbeth*
Solano State Prison, 2015

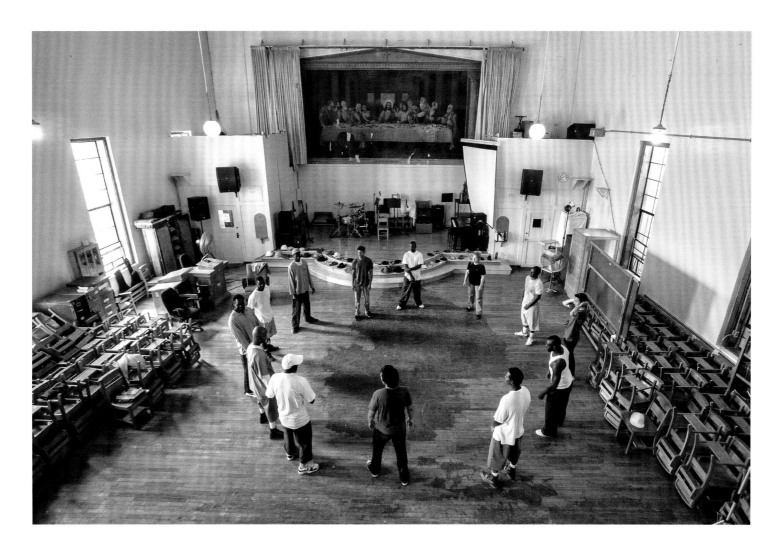

Theater
Folsom State Prison, 2018

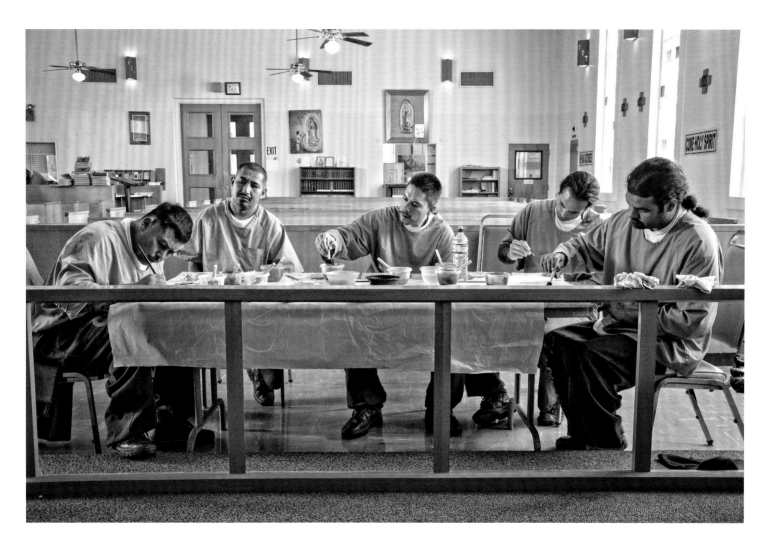

Painting
Sierra Conservation Center, 2016

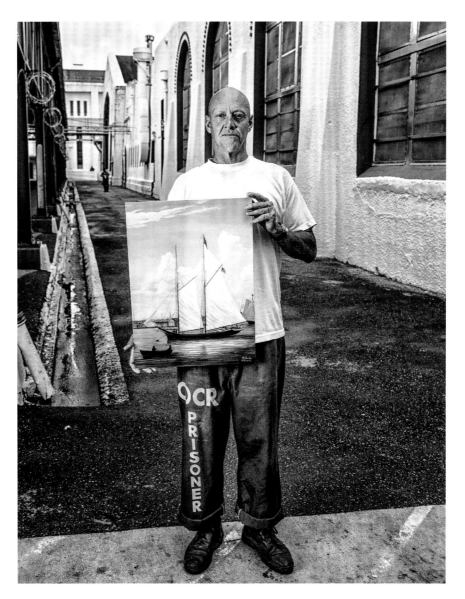

Acrylic painting
San Quentin State Prison, 2012

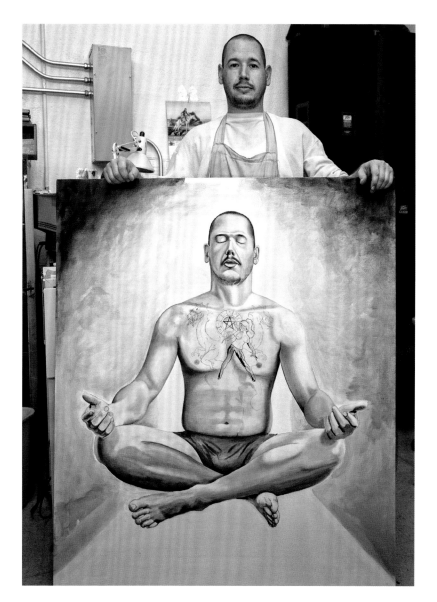

Acrylic painting
San Quentin State Prison, 2006

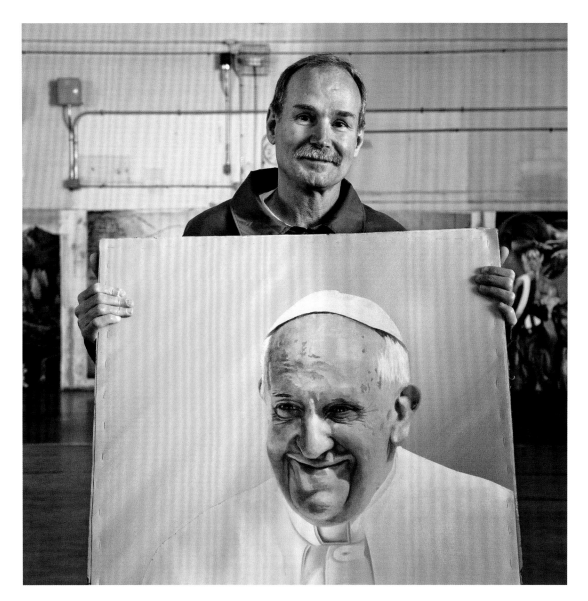

Acrylic painting
California Institution for Men, 2016

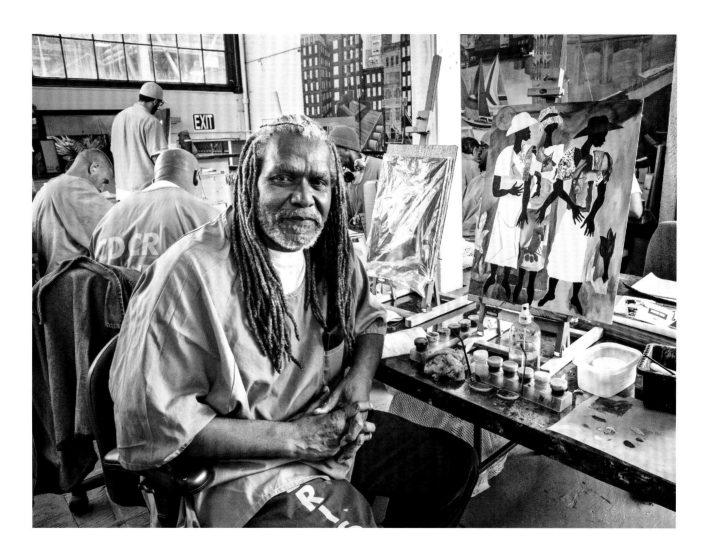

Acrylic painting
San Quentin State Prison, 2015

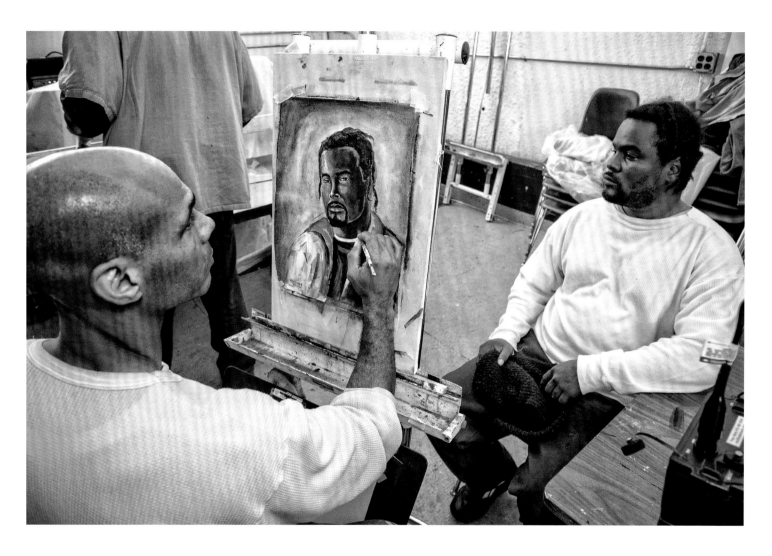

Portrait painting session
San Quentin State Prison, 2006

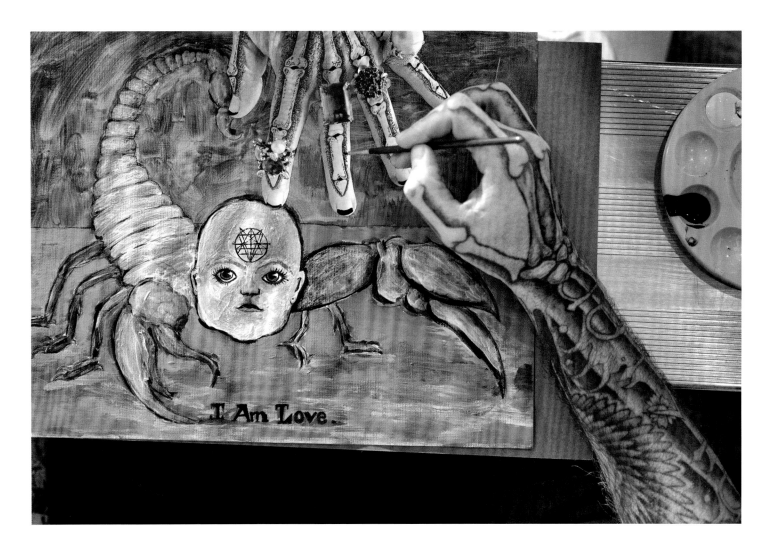

Acrylic painting
RJ Donovan State Prison, 2019

Portrait of a pet
California Institution for Women, 2019

Acrylic painting
San Quentin State Prison, 2006

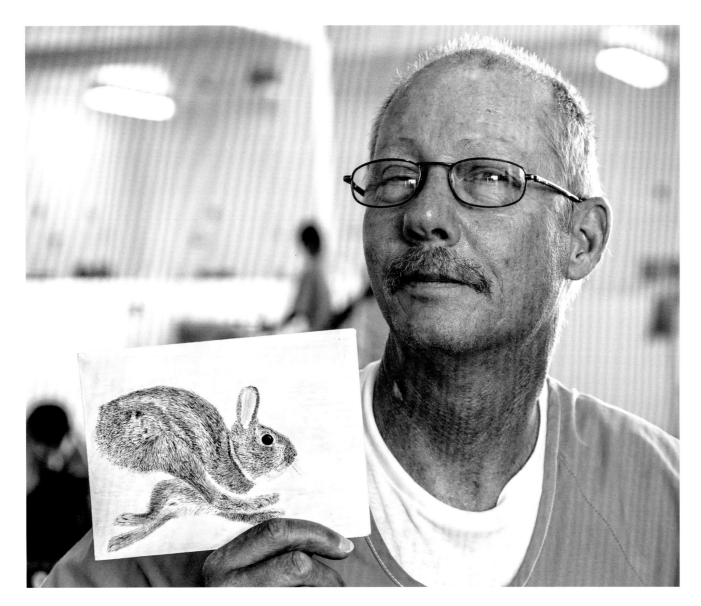

Drawing
RJ Donovan State Prison, 2015

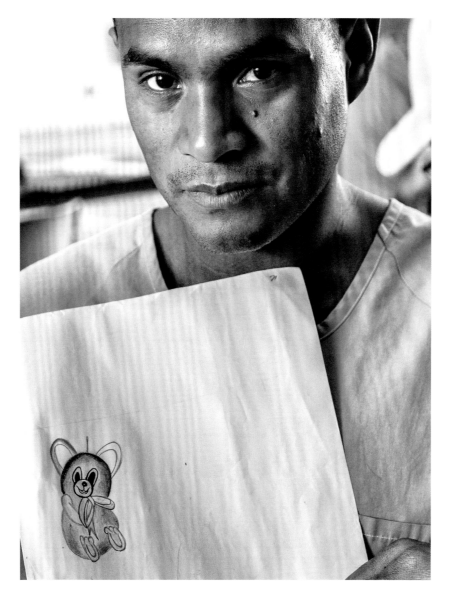

Drawing
RJ Donovan State Prison, 2015

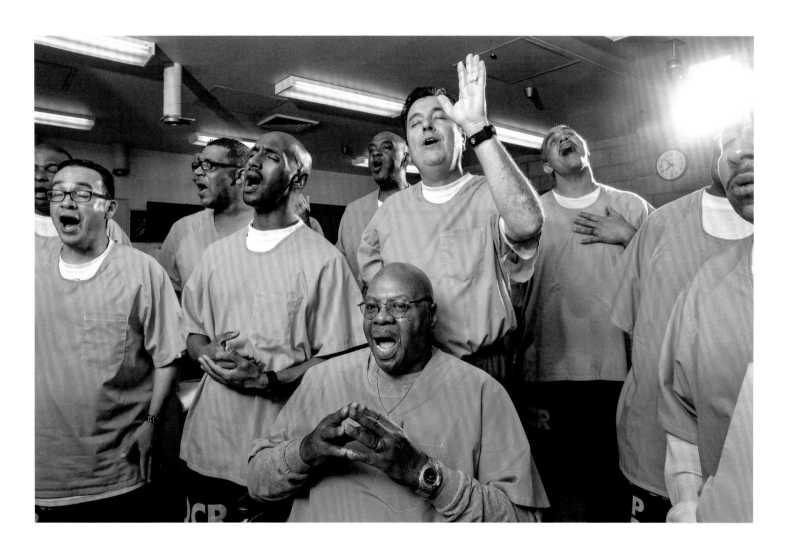

Gospel choir
Valley State Prison, 2017

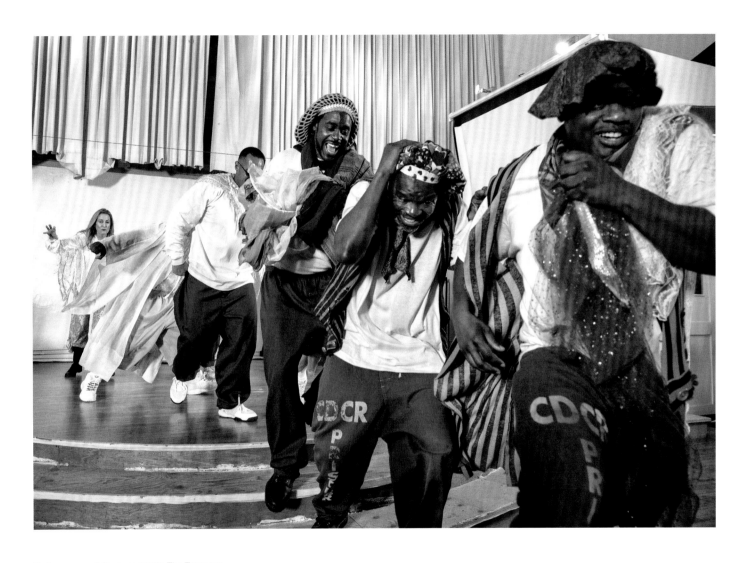

Performance of Shakespeare's *The Tempest*
Folsom State Prison, 2019

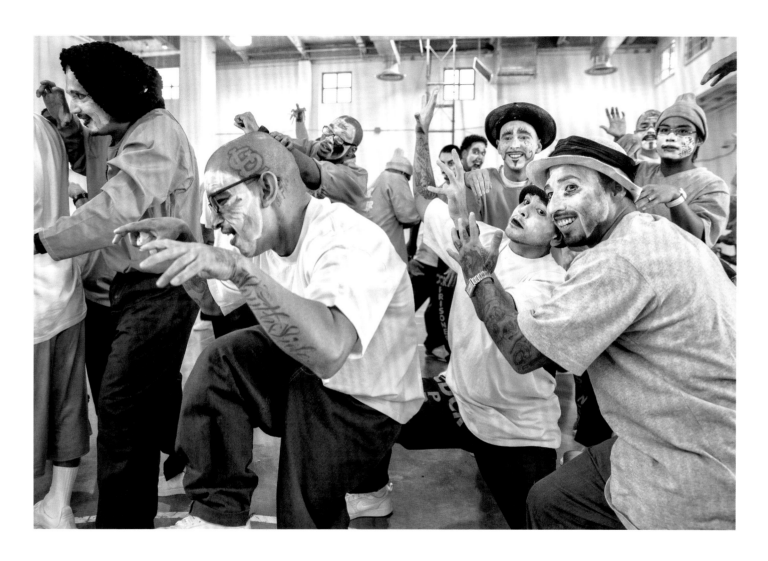

Commedia dell'arte theater
High Desert State Prison, 2018

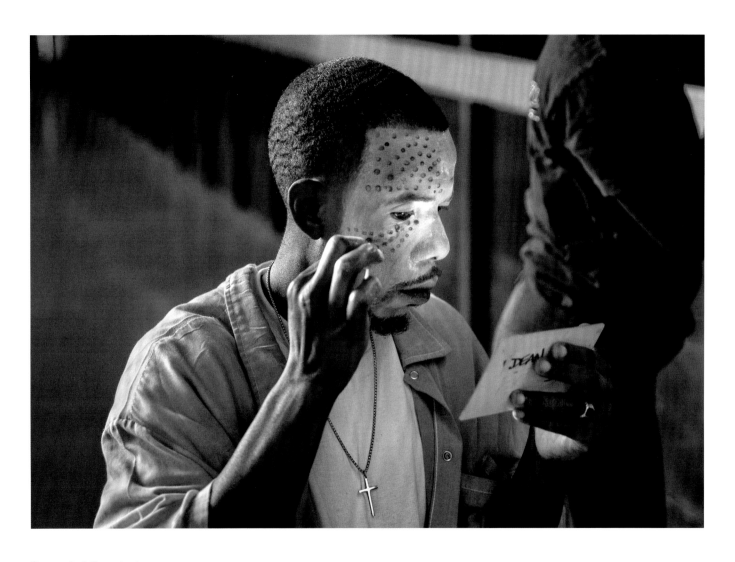

Commedia dell'arte theater
California State Prison Sacramento, 2019

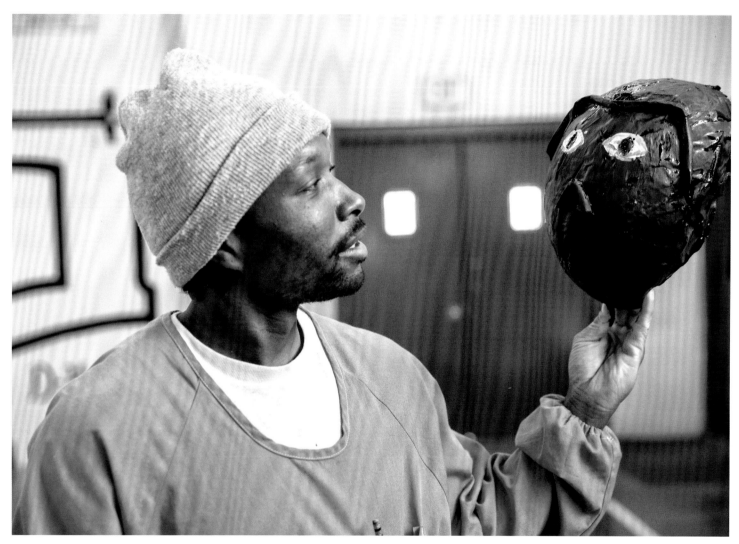

Theatrical mask-making
High Desert State Prison, 2018

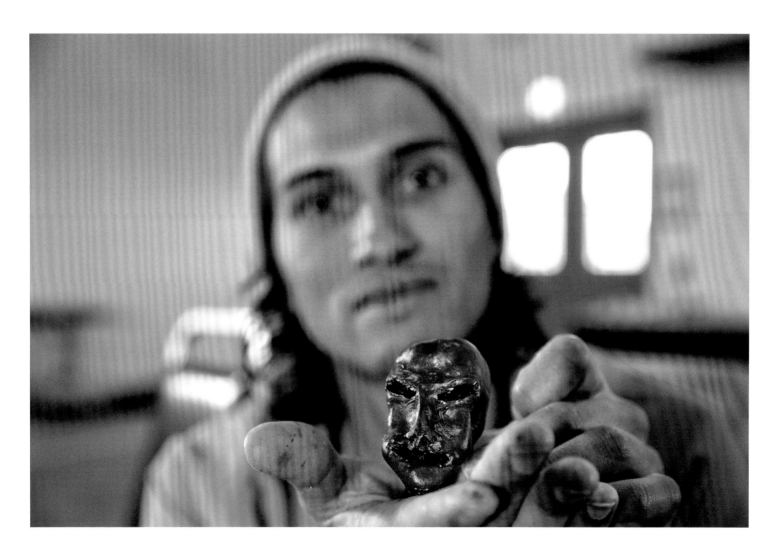

Clay sculpting
Lancaster State Prison, 2019

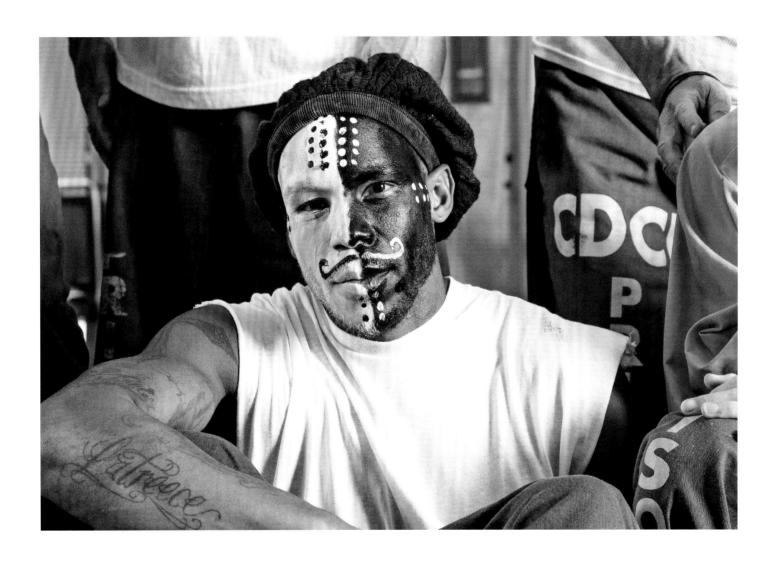

Commedia dell'arte theater
CRC Norco, 2014

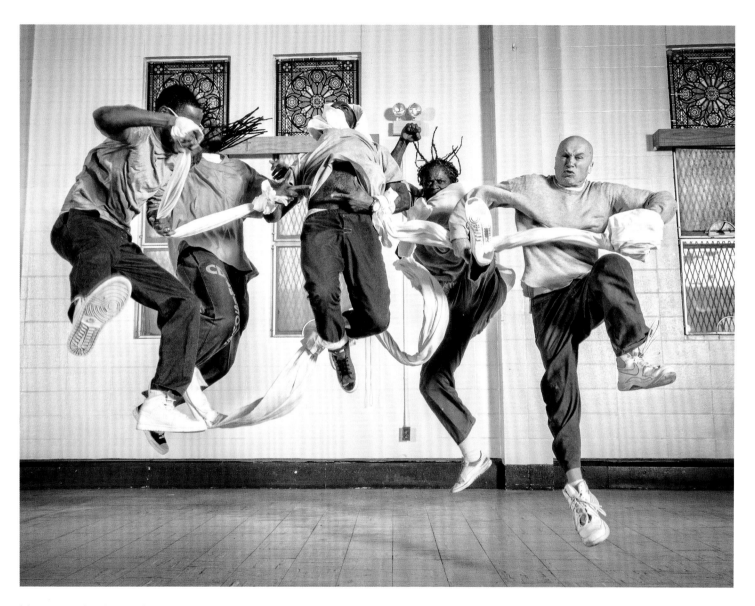

Movement and spoken word
San Quentin State Prison, 2015

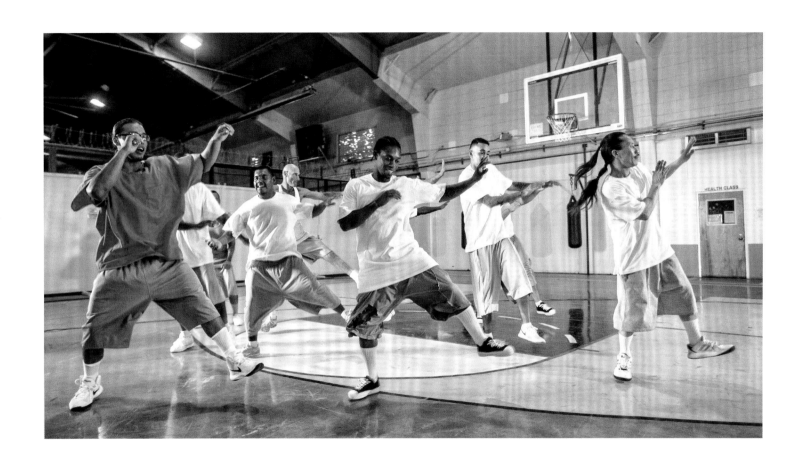

African song and dance
Deuel Vocational Institution, 2019

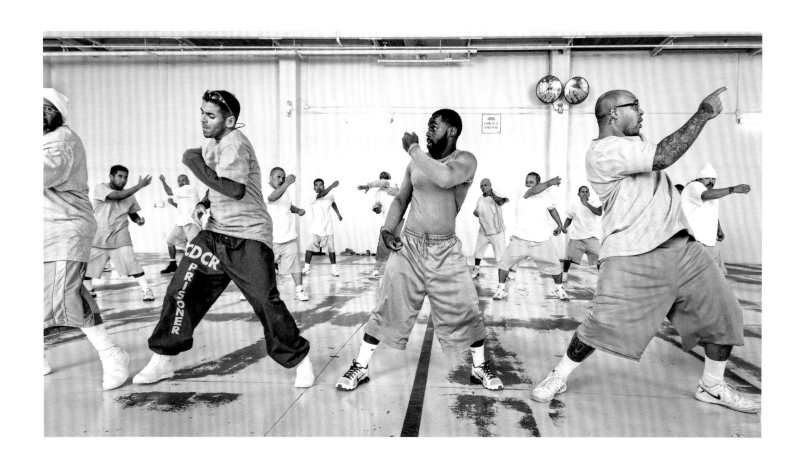

Hip-hop dance
Ironwood State Prison, 2016

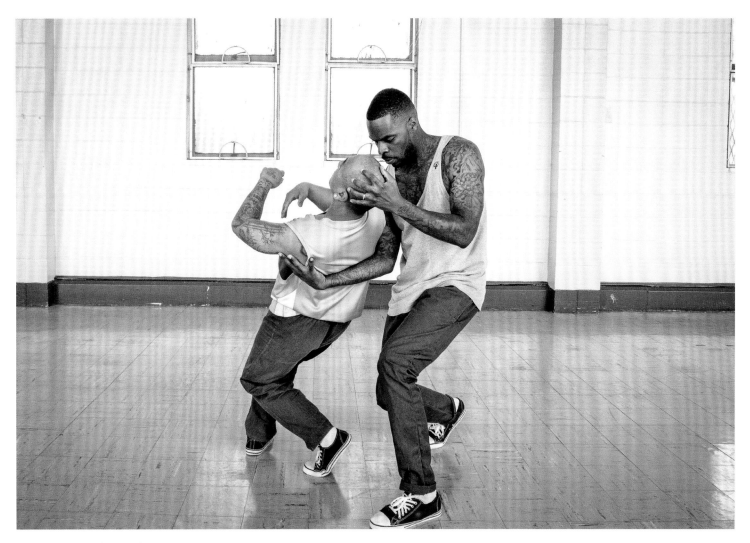

Movement and spoken word
San Quentin State Prison, 2015

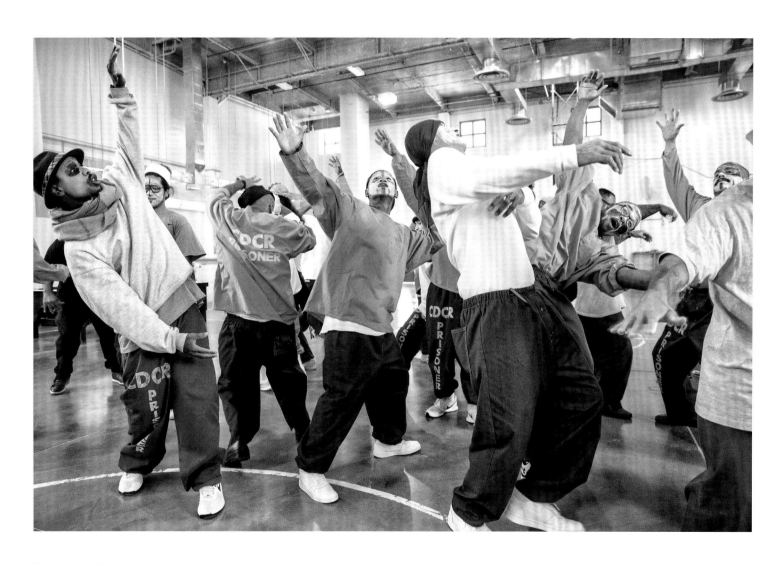

Commedia dell'arte theater
High Desert State Prison, 2018

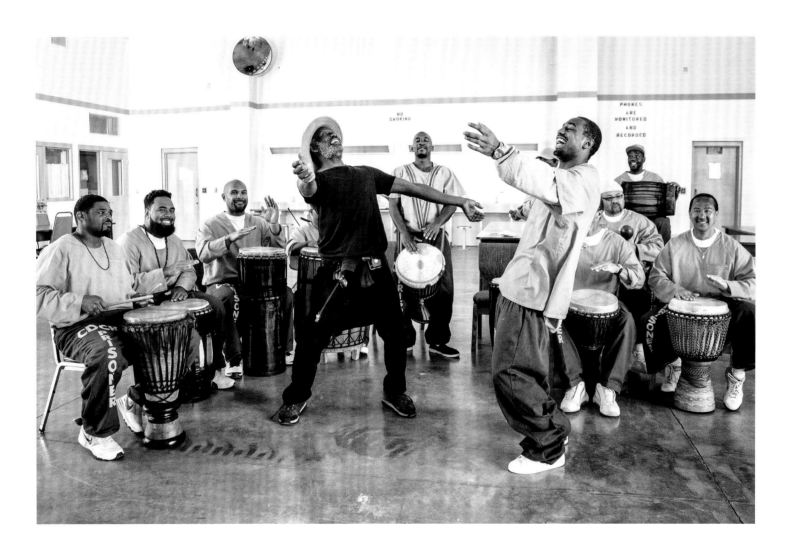

Drumming
Salinas Valley State Prison, 2015

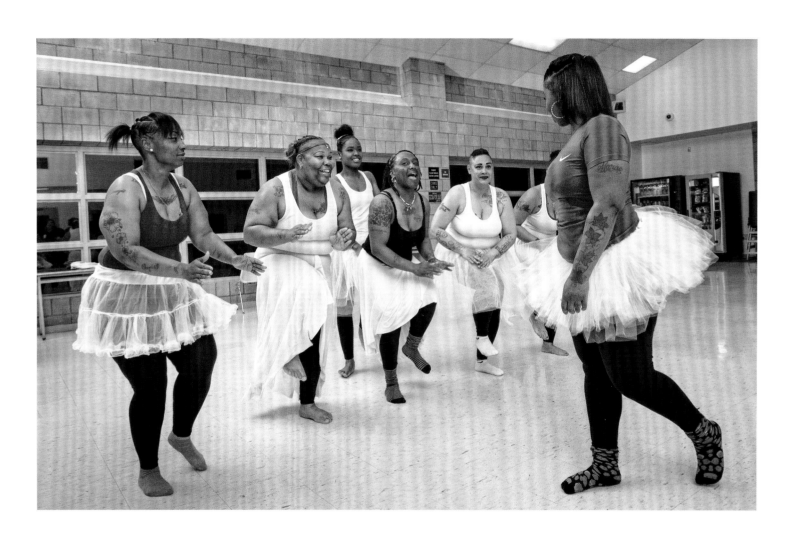

Modern dance
Central California Women's Facility, 2017

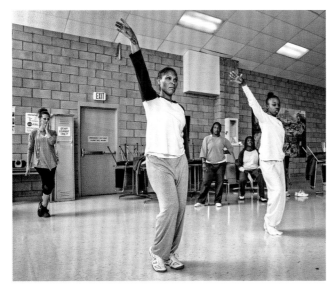

Modern dance, **Central California Women's Facility**, 2016

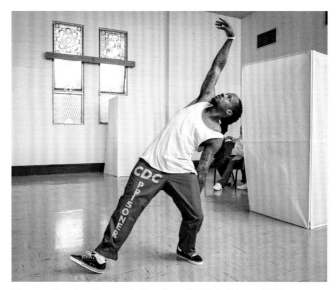

Movement and spoken word, **San Quentin State Prison**, 2016

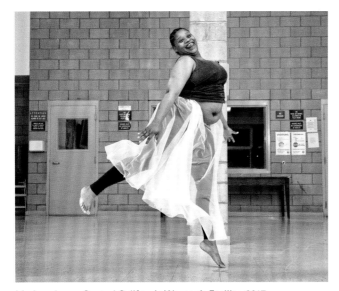

Modern dance, **Central California Women's Facility**, 2017

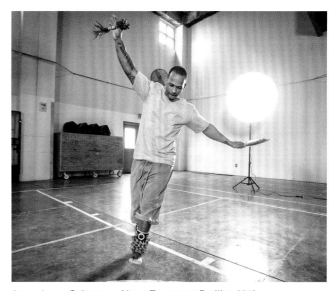

Aztec dance, **Substance Abuse Treatment Facility**, 2019

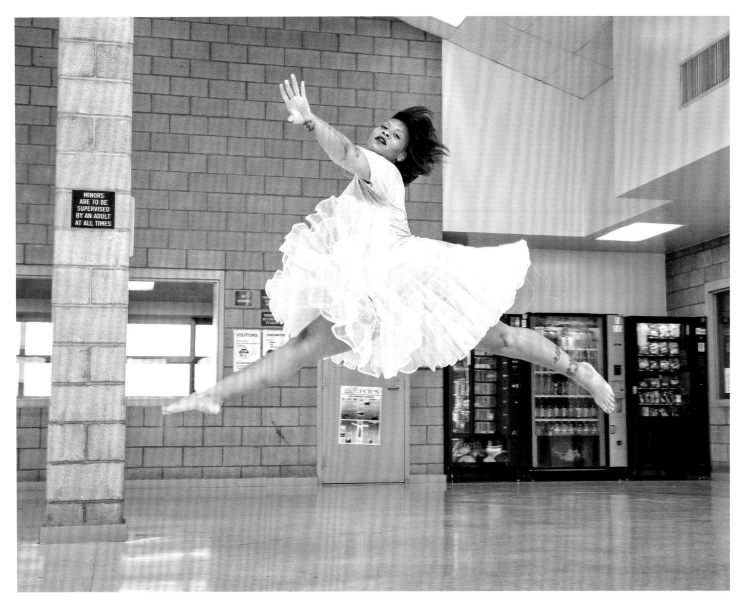

Modern dance
Central California Women's Facility, 2017

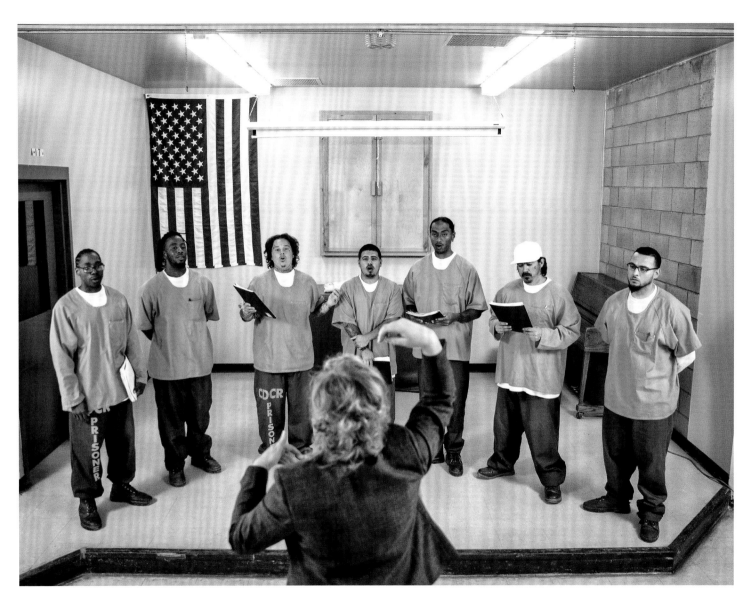

Choral singing
California Correctional Center, 2018

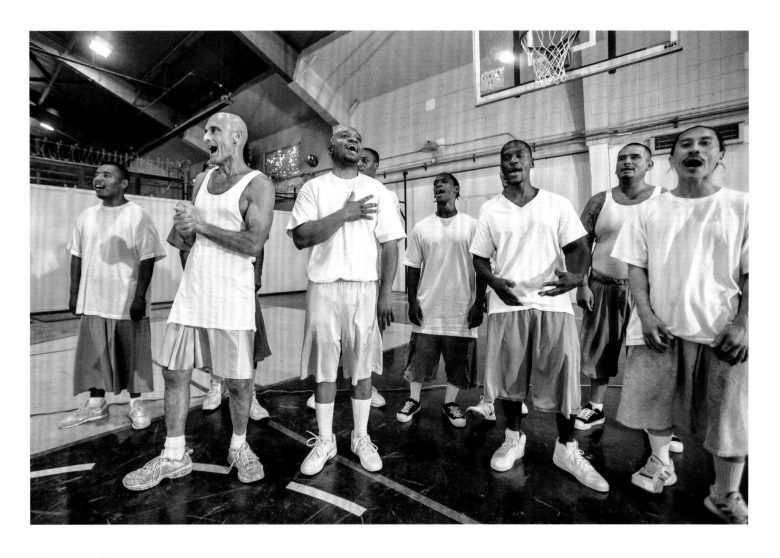

African song and dance
Deuel Vocational Institution, 2019

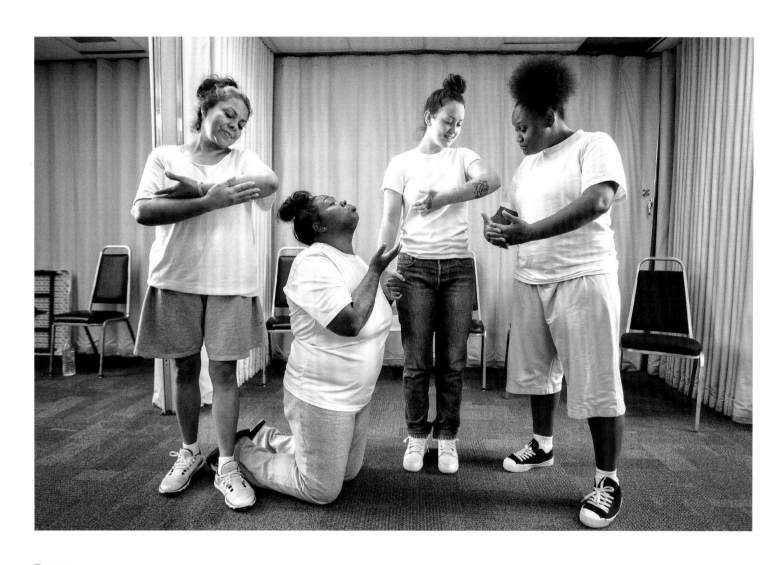

Theater
California Institution for Women, 2019

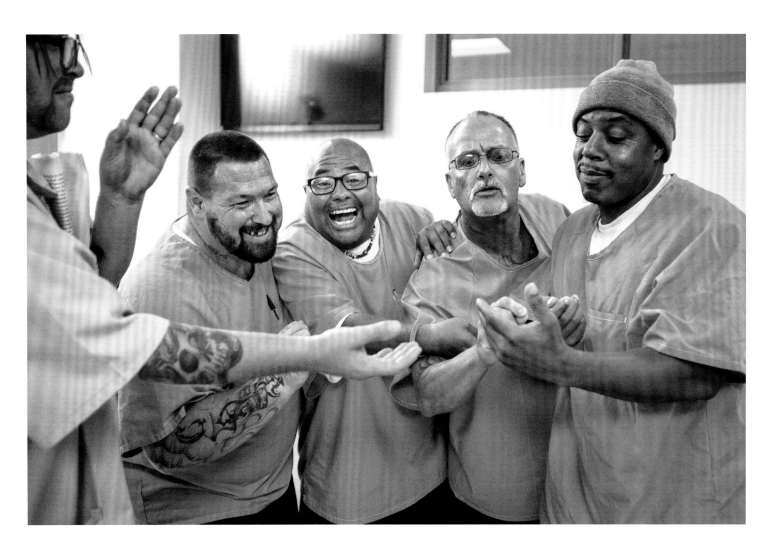

Theater
California Health Care Facility, 2018

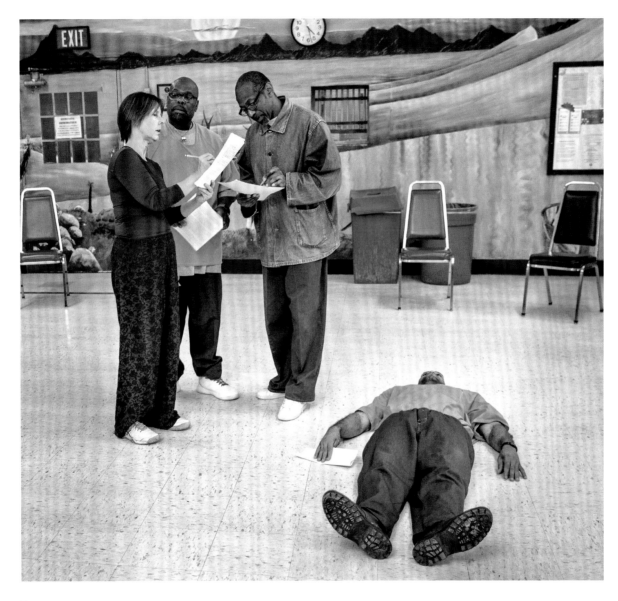

Theater
California Medical Facility, 2018

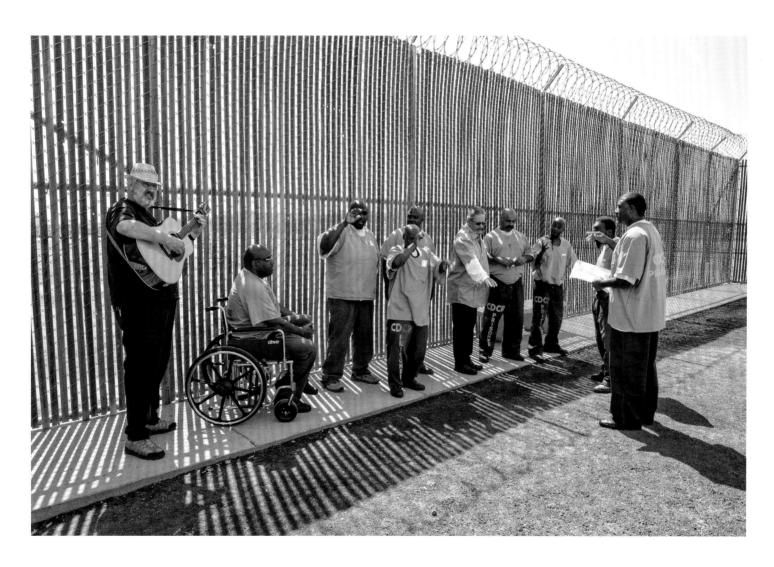

Theater
Substance Abuse Treatment Facility, 2017

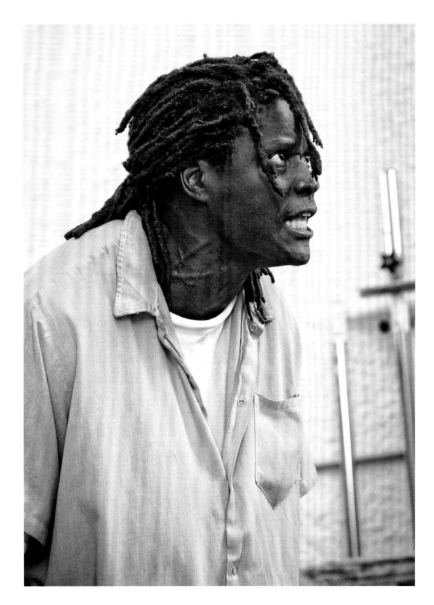

Theater
San Quentin State Prison, 2007

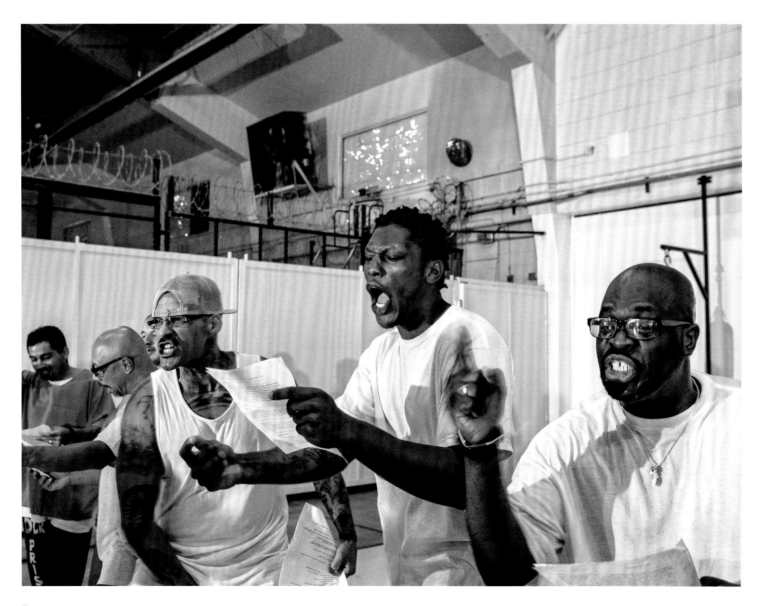

Theater
Deuel Vocational Institution, 2018

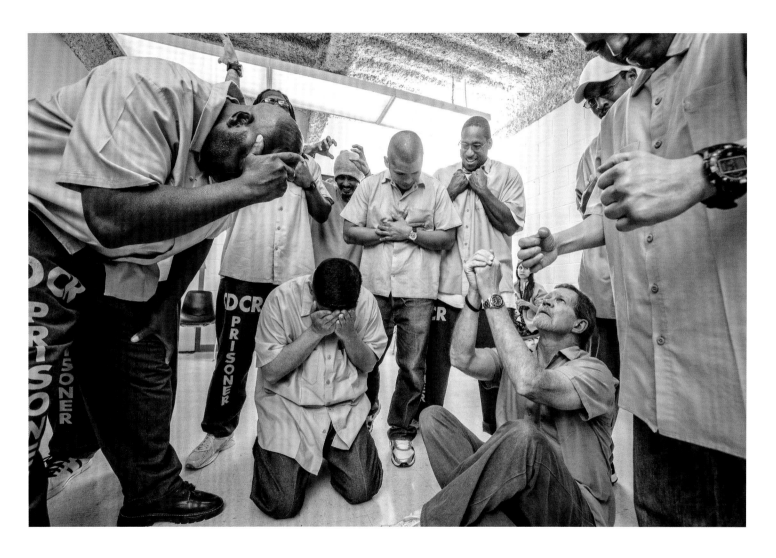

Theater
Solano State Prison, 2015

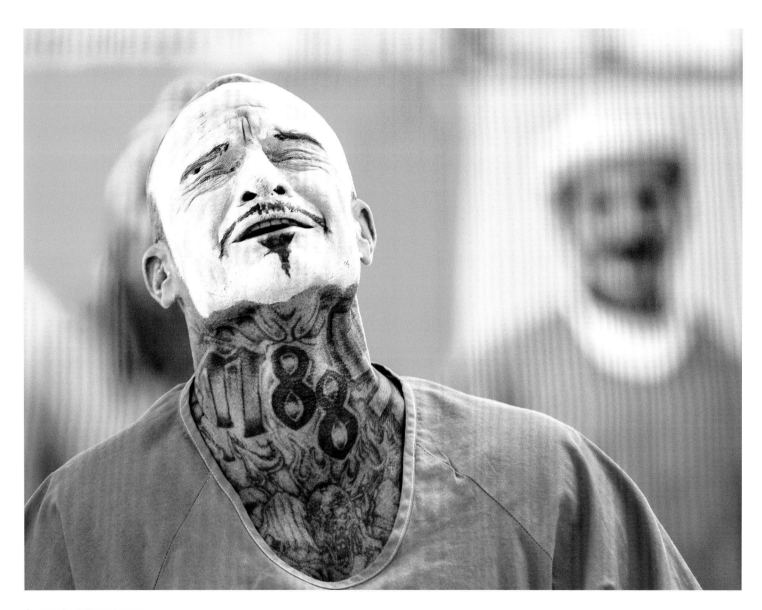

Commedia dell'arte theater
Ironwood State Prison, 2018

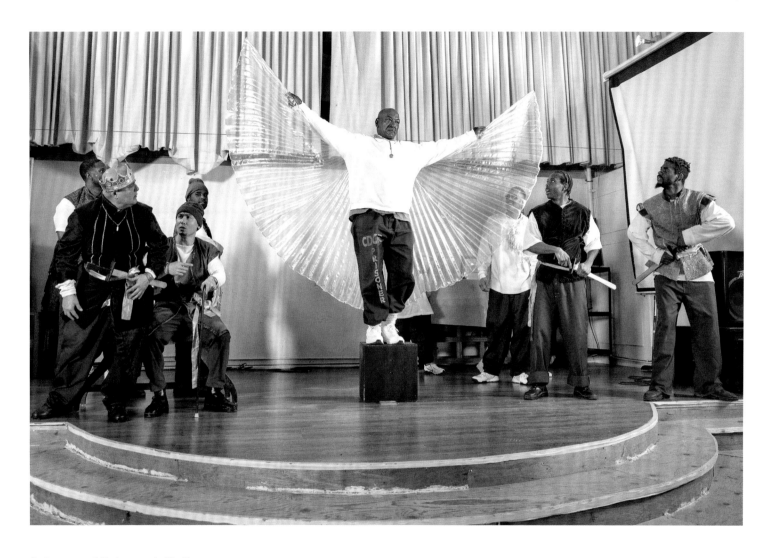

Performance of Shakespeare's *The Tempest*
Folsom State Prison, 2019

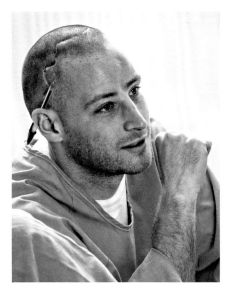

Storytelling, **High Desert State Prison**, 2016

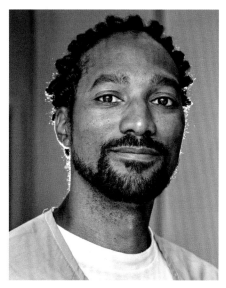

Storytelling, **Avenal State Prison**, 2017

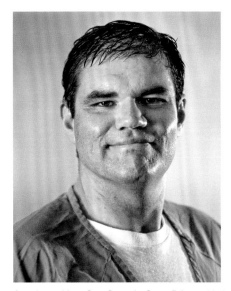

Creative writing, **San Quentin State Prison**, 2016

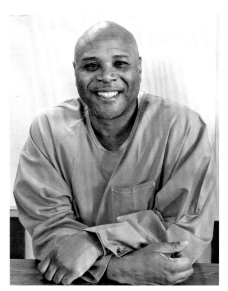

Creative writing, **San Quentin State Prison**, 2016

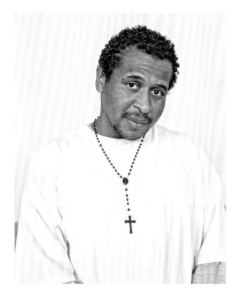

Theater, **Lancaster State Prison**, 2016

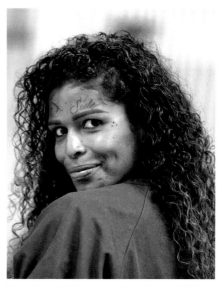

Playwriting, **RJ Donovan State Prison**, 2018

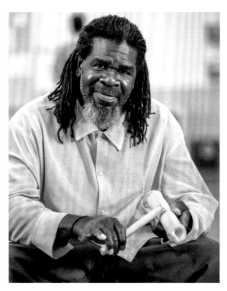

Drumming, **California Treatment Facility**, 2018

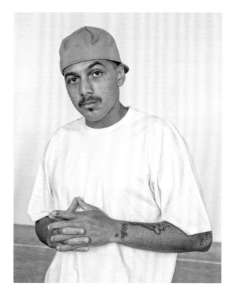

Theater, **Lancaster State Prison**, 2016

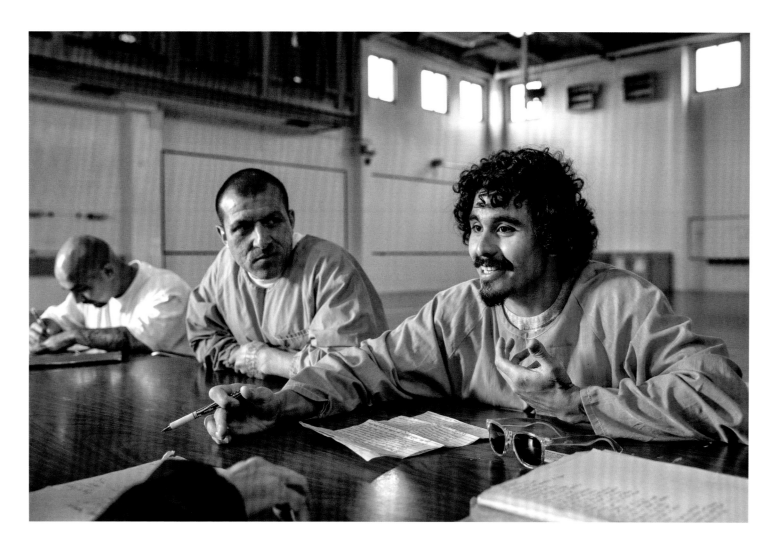

Creative writing
Pelican Bay State Prison, 2019

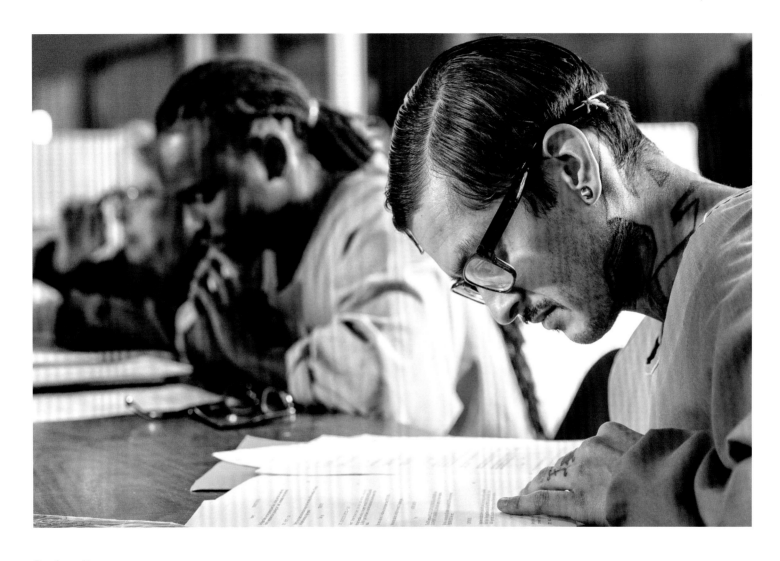

Creative writing
Pelican Bay State Prison, 2019

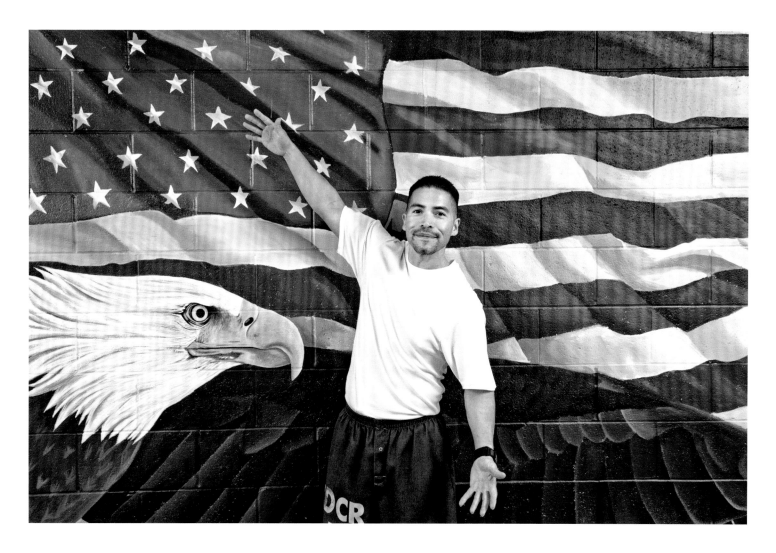

Mural painting
Valley State Prison, 2017

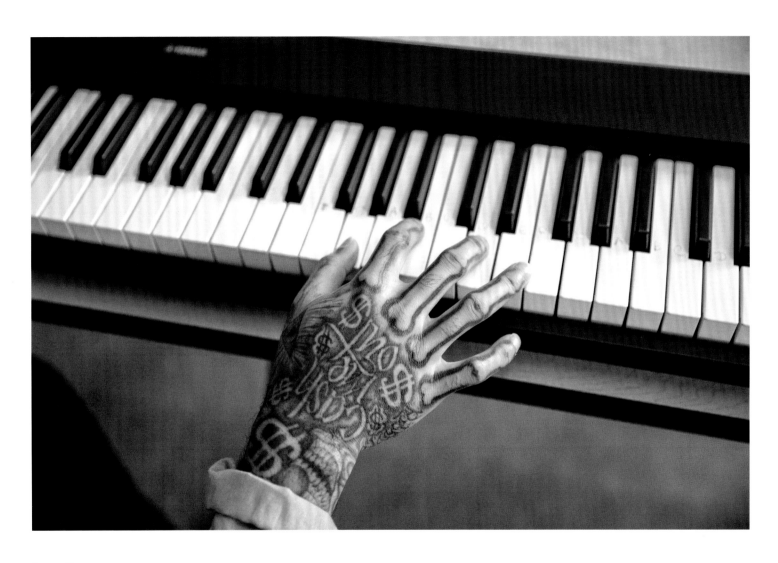

Songwriting
CCI Tehachapi, 2018

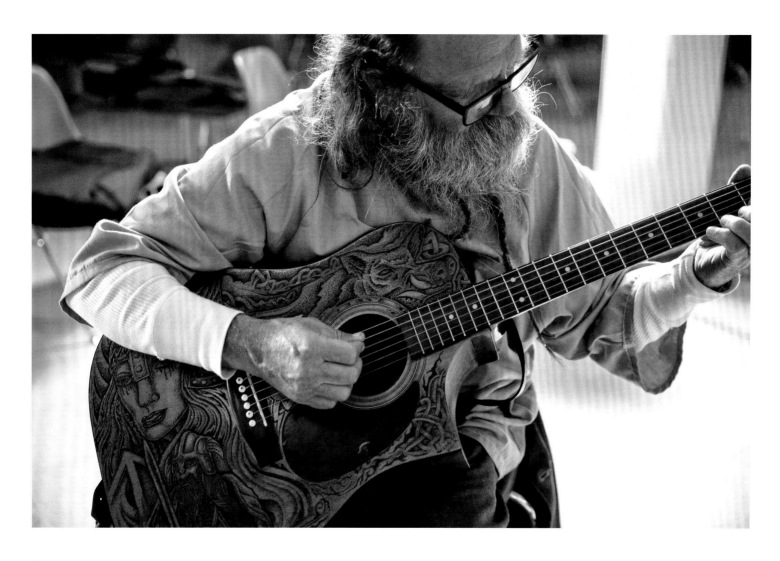

Guitar
Sierra Conservation Center, 2019

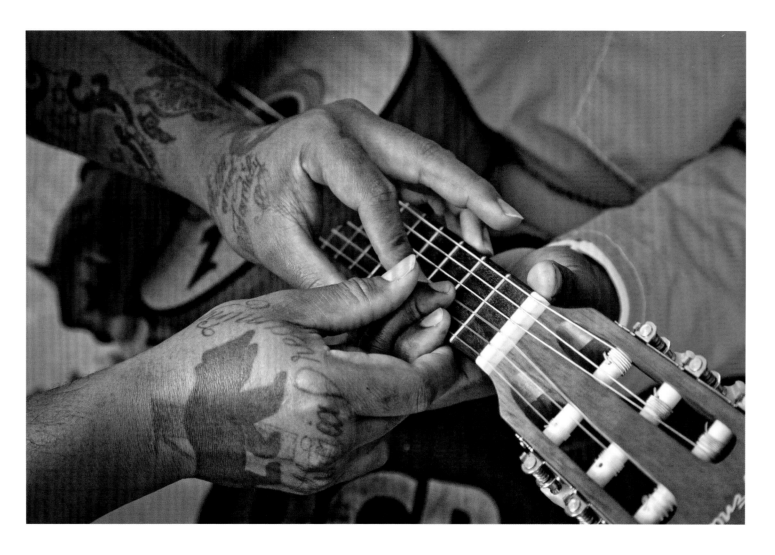

Guitar
High Desert State Prison, 2016

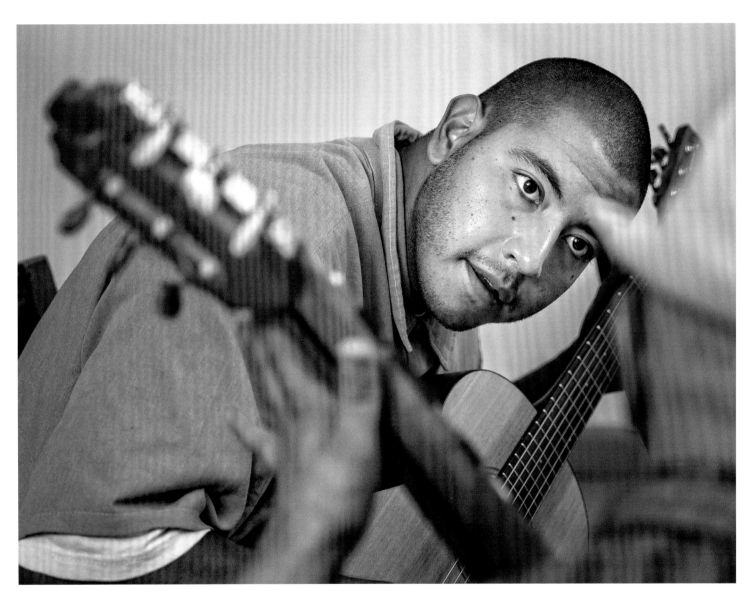

Guitar
North Kern State Prison, 2018

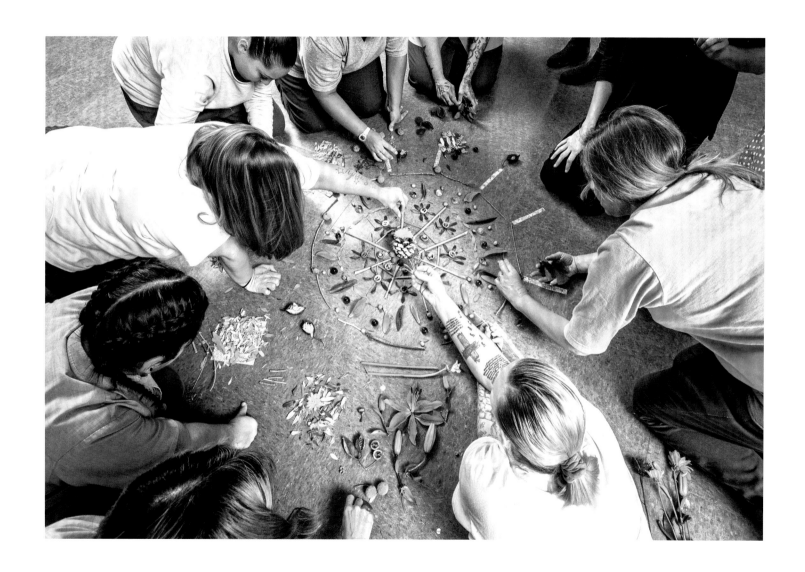

Making a mandala
California Institution for Women, 2016

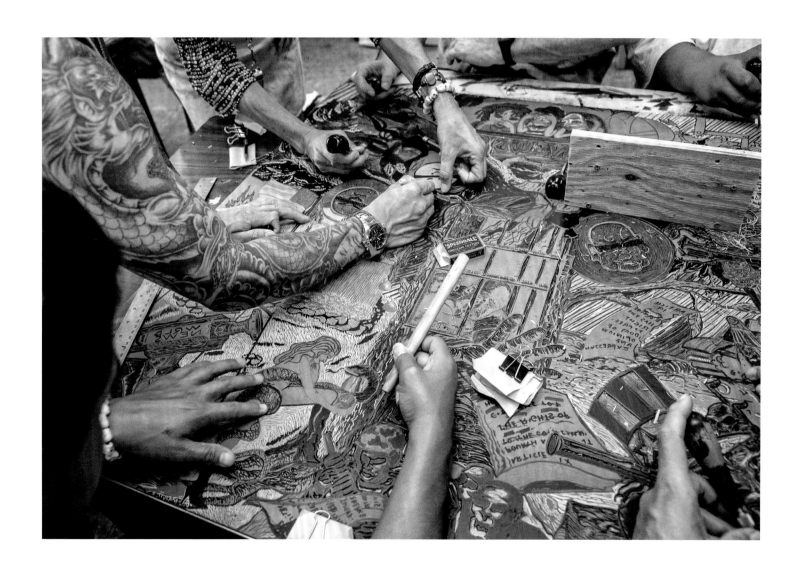

Carving a linoleum block for printing
San Quentin State Prison, 2008

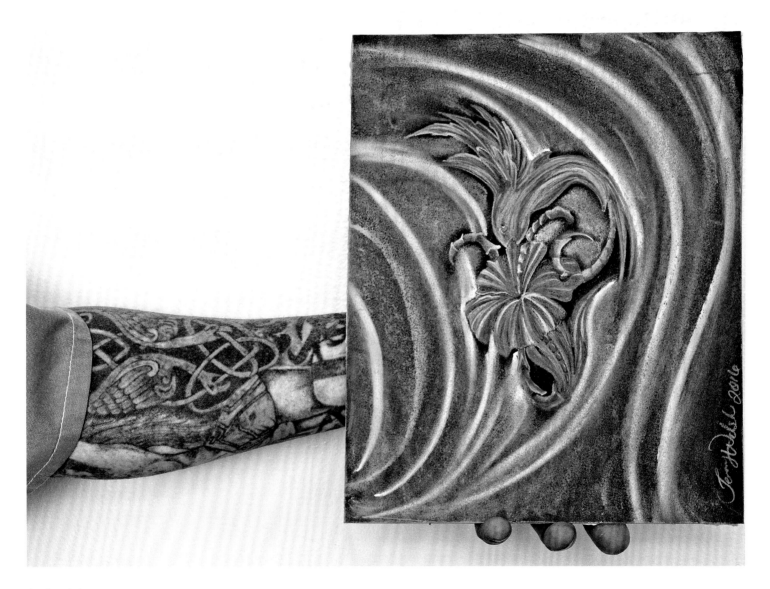

Acrylic painting
Sierra Conservation Center, 2016

Drawing
Substance Abuse Treatment Facility, 2016

Visual arts
Calipatria State Prison, 2018

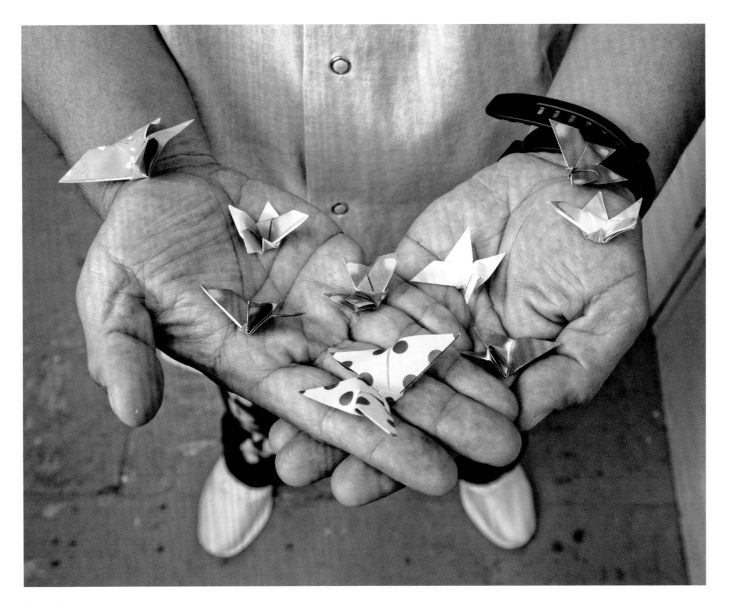

Origami
San Quentin State Prison, 2017

Interview of Peter Merts by Michael Kirchoff

—This interview first appeared on Catalyst: Interviews (www.catalystinterviews.com) on August 17, 2021. It has been lightly edited for length and clarity.

Michael Kirchoff: I'm delighted to have this chance to learn more about you and your work, Peter. Thanks for joining me. Let's start with what it was that first lured you into the photographic arts. Was there a particular event or mentor of any kind that helped usher you into this field?

Peter Merts: Michael, thank you for the opportunity to ruminate over my photography; I expect to learn something!

My foundation in photography was established with my dad, who was a hobbyist; during my high school years, he introduced me to black-and-white processing and printing. However, a serious pursuit didn't begin until fifteen years later when I was working for Bread & Roses (now Bread & Roses Presents), a nonprofit organization in my county that provides free entertainment to institutionalized popula-tions. One day while hosting a belly dance troupe's performance in a nursing home I noticed how gleeful and appreciative the seniors were about the colorful, sinuous, jingling dancers. I thought to myself, This is amazing; someone should be documenting this! Since that day forty years ago, I have been continuously engaged in one or more photo projects. Bread & Roses immediately began using my photos in newsletters and for fundraising, which was quite motivating.

In the early years I took a number of photography courses through the extension program at the University of California, Berkeley. One of my instructors was French photographer Michelle Vignes, who became a long-term supporter of my work. Her appreciation and guidance helped sustain me through periods of self-doubt.

MK: What is your primary objective in photography?

PM: Early in my career I discovered the satisfaction of long-term projects; mine have run from five to fifteen years. Looking back over the arc of my career to date, I notice that most of my projects fall into one of two categories—introspective fine art projects and documentary/advocacy projects that serve my community. An example of the former is my project *Solitude: Lost and Found in the Landscape*; for the latter, see my work for Bread & Roses.

I would say, therefore, that my dual objectives in photography are to learn more about myself and to advocate for programs that serve my community. Oscillation between these two poles appears to be a core part of my process.

MK: Do you study what others are doing and find their influence in your image-making?

PM: I do look at the work of other photographers, though I believe the experience yields more in the way of inspiration than aspiration.

The first photographer who really got my attention was Cartier-Bresson. Looking at my modest library of photo books, I see others whose work I have admired at different points: Koudelka, Keith Carter, Sally Mann, and Pentti Sammallahti. I love the humor of Elliott Erwitt, and the activism of Eugene Smith.

Quite some time ago I trained and then worked as a docent at the Friends of Photography gallery in San Francisco (no longer extant, unfortunately). I would study new exhibitions and then give tours to the public, and that effort led me to appreciate some photographers that I otherwise would not have given a second glance.

MK: You recently took home the 2021 Social Award from CENTER for your work *Incarcerated Artists*. What appears at first glance to be a strictly documentary project seems to be more of a collaborative effort in its execution. Can you tell us how this project came to be and if it's still ongoing?

PM: Earlier I mentioned Bread & Roses as the starting point of my photographic career. During my years documenting and advocating for their work, I photographed a number of their music concerts at San Quentin State Prison, which is near my home. One day I was photographing a Michael Franti concert there when Steve Emrick, who was then running the art program at San Quentin, approached and asked if I would be interested in photographing the art classes. That is how this project began. It is ongoing—or rather, I am planning a post-pandemic resumption as soon as in-person art classes resume and most participants can attend without masks.

You point out that some of my images suggest a collaboration with my subjects. This engagement happened over time, in response to a couple of factors.

Initially I employed the same shooting style I had used for Bread & Roses—I photographed from a distance that I judged to be non-intrusive; I was *looking in* at each scene as an observer. However, this style soon seemed a poor fit for the mood of the art classrooms—which tend to be open, trusting, collaborative, and often playful. [Here I give a shout-out to the teaching artists, who are responsible for establishing the classroom tone!]

I felt drawn to this upbeat energy; I wanted to participate rather than observe. More to the point, I wanted the viewers of my images to feel this positive energy, so I began to move in closer, and to explore the possibilities of collaboration with my subjects. Thankfully, the artists welcomed me in. I now regularly step into the midst of things during class. For theater and dance classes in particular, I feel like I'm dancing with the students as I flow with the energy and step lively to avoid collisions.

Whenever time and interest allow, at the end of a class I will offer to make portraits of the students. Since they know their families will be able to see the images, I generally get enthusiastic participation. The portraits are a great opportunity for collaboration—together, we decide how they will be portrayed.

The other factor that led me to a more collaborative shooting style was the reaction I sometimes get from members of the public, when I show them photos of prison arts programming. It boils down to some version of "they don't deserve art classes"—which, besides missing the point, suggests that incarcerated people are incorrigible, irredeemable, or somehow less than human. Of course, research demonstrates that incarcerated people benefit greatly from art programs—but how do we elicit compassion and empathy for those locked away? My solution is to engage directly and almost intimately with these

artists when I photograph them, to directly reveal emotions, moods, and personality. My goal is to illuminate their humanity.

MK: These photographs of prison life are bright and vibrant and appear as more of a celebration than a sentence. Prisons and the incarcerated are often held in a dark and negative light, but you show us another side, which is rare. Were the methods to make these photographs planned out this way, or was it its own process?

PM: Most of the rooms where art classes are held have little or no natural light. The institutional lighting is dim, mostly fluorescent, and relentlessly overhead—resulting in scenes that are flat and muddy, and faces with inscrutably shadowed eyes. It makes everyone look—well, like criminals.

As mentioned before, my experience of these classes is just the opposite. There are good vibes and a busy, healthy industry. People are helping each other, laughing together, listening intently to the instructor. There is an air of agency and optimism. I want my photos to reflect this mood, so I boost the light in most scenes with two strobes on stands. With umbrellas, cords, light stands, etc. I have a pile of gear; I wheel it into and out of the prisons in a collapsible cart.

Adding light has the additional advantage of helping viewers to see and read the faces. One of my goals for this project is to disrupt the public's conceptions of incarcerated people. By showing these artists interacting with mutual respect and authenticity, again, I hope to illuminate their humanity.

The *style* of lighting I use has changed over the course of this project. Initially I bounced strobes off the walls and ceilings; this gave a broad, shadowless light that is quite revelatory and makes colors pop. However, that style lacks drama and was becoming boring, so with the encouragement of some fellow photographers I have transitioned to direct lighting using umbrellas. It requires me to reposition the lights as I work the room, but results in images with more depth and drama.

Incidentally, if I have time during setup I gel my lights to match that of the ambient bulb lighting, which reduces background color casts.

MK: It does make sense that something like art therapy would benefit an inmate's mental health or rehabilitation. It certainly helps us outside of prison walls. Have you been able to watch substantial progress with any individuals and even perhaps seen them move forward after release because they participated in these classes?

PM: During the fifteen years I've done this work I have definitely seen transformations. One example is a man I'll call "Allen."

Allen is currently incarcerated at California Men's Colony. While still in high school, Allen's life began to go off the rails. His relationship with his parents went sour and he began running with a gang. One night Allen and a few of these new friends assaulted a homeless person in Los Angeles. The man died, so at eighteen years old Allen—instead of starting his senior year of high school—went to prison for murder.

For his first few years in prison, Allen was unrepentant; he continued his gang affiliation on the inside. Visitation with his mother was awkward and unsatisfying for both of them. Eventually, Allen left the gang and turned his life around. He began

taking education and self-help classes. He signed up for prison jobs, including one as a caretaker for a disabled fellow inmate. He reestablished open, respectful, loving relationships with his mother and father. He will have his first parole hearing in early 2022, after twenty-two years in prison.

Allen attributes his turnaround to the prison men's group he joined and to the art classes. In particular, Allen showed a talent for classical guitar and for creative writing. He credits his art instructors for seeing something valuable in him that he could not see himself.

I know of a number of men and women who are out of prison now and still work avidly on their art in spite of the massive challenges facing those rejoining free society. Some of them are now working for the same arts organization that brought them instruction inside prison. Others stay in touch informally with the instructors and organizations who taught them inside; they speak at prison reform conferences and give media interviews about their experiences with prison art programs. Against all odds, some recently released artists exhibit and sell their art.

MK: In your artist statement, you mention childhood trauma, and indeed our past dictates a considerable amount to our growth as an individual. How has trauma shaped both this project and you as a photographic artist?

PM: The trauma I experienced growing up resulted in a depressed and directionless young man. After years of floundering, I got the professional therapy I needed. Around the same time, I discovered photography as a means for both exploration and expression. In the decades since, photography has become an essential part of my healing and my identity. More generally, I

have come to recognize art as a powerful tool for introspection, empowerment, and transformation.

One specific way that my trauma impacted my photography is that, in response to the danger in my home, I developed a heightened sensitivity to people's emotional states. This is useful when photographing people.

Many, if not most, incarcerated people have experienced childhood trauma. I think my own experiences with trauma have allowed me to appreciate the psychic damage that can be wrought, and have therefore rendered me more understanding and empathetic—especially toward those who were damaged as children. My own healing journey has also taught me the wisdom of asking for help and the value of forgiveness.

MK: Any exceptionally interesting stories from one of your shoots?

PM: The most embarrassing episodes I experienced during a prison shoot were my own fault. Once while rushing about, I tripped over my own light stand. Fortunately I rolled when I hit the floor, cradling my camera to my chest. For a few moments I was the focus of the class.

Then I twice pulled over a light stand. As you can imagine, a nine-foot-tall light stand crashing to the floor during an art class will make an impression. Fortunately, no one was hurt. I now move my lights more carefully and use heavier stands. I also make sure to keep my insurance up to date.

The most poignant episode occurred not *during* an art class, but months afterward. Norton Buffalo, master of the blues harmonica,

held a one-day instructional workshop with some of the musicians at San Quentin. He drove three or four hours from his home, conducted the workshop as an unpaid volunteer, then drove another three or four hours to get home. Norton was a gracious, generous, respectful instructor. At one point, to demonstrate a particular throat technique, he went separately to each student in the class. As he blew a riff, he invited each student to place a hand on his throat, to feel the vibrations of his vocal structure. As people in prison generally don't touch each other, it was a rare moment of consensual intimacy between Norton and each student. Norton's offered vulnerability in the moment seemed like a gift. We didn't know it at the time, but Norton was ill the day he gave that workshop; months later he passed away from cancer.

Some may find it remarkable that I have not witnessed any violence or threat of violence in the roughly 240 prison art classes I have visited. In fact the men and women value these classes so highly—some of them call the art room their "sanctuary"—that they avidly police themselves for any behavior that might interrupt the program.

I was once in a printmaking class at San Quentin—one of the few California prisons that allows the use of cutting tools—when one of the artists asked the room, "Hey, who has the #3 cutter?" When no one replied, the room collectively caught its breath; loss of a strictly inventoried steel cutting tool would shut the program down for a month or more. After a nervous search the missing cutter was found on a table, under a sheet of paper. There was an almost audible sigh of relief, and people returned to carving their linoleum blocks.

MK: Is there a long-term goal for *Incarcerated Artists*?

PM: I would love for these images to have a positive impact on prison reform policy. In fact, I have been told that an earlier book I co-published with Dr. Larry Brewster did have such an effect. *Paths of Discovery: Art Practice and Its Impact in California Prisons* (2nd ed.) includes my photographs of prison art classes; the artwork and writings of, and interviews with, incarcerated artists; a summary of the research showing the abundant, cost-effective benefits of prison art programs; and a brief history of California's Arts in Corrections program (virtually all of the prison arts classes I have photographed are part of AIC).

It has been said that *Paths of Discovery* was influential in persuading the California legislature to resume funding of Arts in Corrections, some years after the program was completely defunded as a result of the Great Recession. For anyone working in advocacy photography, this kind of result is the ultimate payoff.

Of equal importance is my desire that these photographs will illuminate the humanity of incarcerated people and bring comfort and hope to the artists and their loved ones.

MK: Anyone working in an artistic field has matured and grown over time. Is there anything you've discovered lately that you'd like people to know about you or your creative process?

PM: This may be true for most artists, but it's important for me to keep learning—about both myself and my craft. I love to step toward the unknown with every new project.

I typically like for a new project to be very different from any recent ones. This helps me to let go of former concepts, methods, and styles, allowing me to develop these afresh. For example, my last major project prior to *Incarcerated Artists* was

called *Solitude: Lost and Found in the Landscape*. It was shot on black-and-white film across multiple continents, has an introspective point of view, and contains a lot of nature and absolutely no people. It's very different from *Incarcerated Artists*.

The level of collaboration—both within and beyond the photo sessions—I've embraced with this current project has been enlightening. Photography can be a lonely pursuit but does not have to be. I have become immersed in the society of prison arts programming and penal reform and I can report that it is a warm, intelligent, sustaining community.

I would be remiss not to mention here my technique for addressing creative blocks and conundrums. When I get stuck on an artistic or personal issue, I take a walk. A long one, in nature if possible, often with a paper and pen. These questions you posed set me off on several treks.

MK: What steps do you pursue to find an audience for your photographs?

PM: For this project, the audience closest to my heart are the family members of the incarcerated artists. Some of them have told me how important these photos are to them—especially those who live far away or are otherwise unable to visit their incarcerated loved ones. So before I begin photographing any art class, I hand each student a slip of paper containing my website URL and the click sequence to find the photos; I instruct them to pass the info to their loved ones on the outside.

Edited photos from the shoot are posted within a week or two after the shoot; families are allowed to freely copy and use the images. I also make unlimited prints available to the families, at cost. Prison rules forbid my giving anything to the student artists themselves; this scheme is my workaround.

I also give these images to the prison teaching artists and the arts organizations that employ them, to the California Arts Council, and to the Department of Corrections and Rehabilitation. Likewise, I distribute the images for use in articles, films, textbooks, blogs, websites, exhibitions, and slideshows pertaining to prison reform and social justice. They have appeared in the *New York Times*, the *Washington Post*, the *Huffington Post*, the *Economist*, the *Guardian*, the *Los Angeles Review of Books*, and elsewhere.

Incidentally, I ask the instructors to inform their class at least a week in advance of each photo shoot. This allows the students to consider in advance whether they want to be photographed (occasionally one or two will demur) and allows them to plan for hair and clothing (wardrobe choices are limited!) for shoot day. This advance notice is particularly useful for visual artists, because we ask them to bring on shoot day any completed work they have in their cell. If the artist desires, I photograph these paintings, drawings, prints, sculptures, etc. and post the reproductions on my website for their families to see. Some artists obtain prints of their art from a family member, then show them proudly during parole hearings.

Lately I've been seeking audiences for this work outside its home habitat of prison reform and social justice circles. To this end, I participate in portfolio reviews and submit my work to photo competitions and publications.

MK: In speaking to future generations of photographers, do you have any words of wisdom to those setting out to make their mark in the photographic world?

PM: First of all, I recommend finding a project that will make a mark on the photographer themself. Only projects that have deep resonance will be sustainable over the long haul. The right project develops its own momentum and confers a certain authority on the photographer.

Secondly, consider a project that will leave a positive mark on your community. Or on some community to which you don't yet belong.

Thirdly, seek feedback from knowledgeable, reliable people on how to improve your project, and how to get it seen. Portfolio reviews by experts or even peers are great for this.

And finally, don't give up! If you have been told by people accomplished in photography that your project is worthwhile, that it needs to be seen—then push through the rejections that will inevitably come your way, and keep trying. I received a lot of rejections before landing opportunities to show *Incarcerated Artists*.

MK: A final question. How do you see your work progressing into the future? Do you have anything new you are currently working on that we should be on the lookout for?

PM: I will likely continue with this project for a while; I think there is untapped potential. My photos are still useful in the prison arts community, and I feel compelled to further explore collaborative portraits. After a fifteen-month Covid-dictated hiatus from visiting prisons, I just renewed my California prisons security credentials.

I will take this opportunity to announce that I am publishing a monograph of these photos with Daylight Books; it is scheduled for release in the spring/summer of 2022. The working title is *Ex Crucible: The Passion of Incarcerated Artists*.

I'm also thinking of creating books from some of my older projects. Top of mind are the photos I made on Little Cumberland Island, a wild and isolated island off the coast of Georgia where my parents had a vacation home in their later years. My current plan is to include my landscape images as well as snapshots of my family on the island.

I am currently working on one other project. I love walking in nature and live in a beautiful area just north of San Francisco. I meander in the hills here quite often and have dreamed of doing a photo project related to these jaunts. I haven't yet figured out my point of view; it's a work in progress. The working title is *Foot Notes*, as I'm working at this point with a handheld street photographer's camera.

Michael, thank you so much for the opportunity to think and speak about my photography. It has been edifying!

Acknowledgments

My photo documentation of art programs in California prisons would not have been possible without extensive support from the California Department of Corrections and Rehabilitation. Thanks to the Department of External Affairs and especially Chief Krissi Khokhobashvili, who championed this project from the beginning. My deep appreciation goes also to each institutional warden, public information officer (PIO), and community resource manager (CRM) who arranged and hosted my visits. Special thanks to San Quentin State Prison, which is near my home and where this project began—especially to PIO Lt. Sam Robinson and former CRM Steve Emrick, who gave me unprecedented access to the prison's programs.

I have deep gratitude for the California Arts Council (CAC), which administers the state's Arts in Corrections program. Many of the photos shown here were made while I was under contract with the CAC, and the staff has given considerable assistance in this project.

When not under that CAC contract, my documentation visits have been at the request of the provider organizations—the regional nonprofits and arts councils who recruit, hire, and manage the teaching artists. These providers have been dream partners in this work. I have photographed prison art classes run by the following: Alliance for California Traditional Arts, The Actors' Gang, Artistic Ensemble, Arts Council of Kern, Bread & Roses Presents, Dance Kaiso, Fresno Arts Council, Fugitive Kind Theater, Give A Beat, InsideOUT Writers, Jail Guitar Doors, KALW Radio, Marin Shakespeare Company, Muckenthaler Cultural Center, No Joke Theater, Playwrights Project, Prison Arts Collective, Project PAINT, Red Ladder Theater Company, Riverside Arts Council, Theater-Workers Project, We Heart Art, and the William James Association. I give a special shout-out to the William James Association and the Prison Arts Collective (PAC), both of which have been supportive in countless ways; and to Annie Buckley of PAC for her beautiful essay. Also deserving of kudos is California Lawyers for the Arts, a fierce advocate for prison art programming and a great partner to me in publicizing these photographs.

Very special thanks to the class instructors who are not only talented and generous teachers, but also responsible for crafting the culture of each class—which I found to be supportive, playful, collaborative, and professional. And a huge thank-you to all the student artists who gracefully accepted me into their midst and allowed me to dance with them for a while.

For decades I have been photographing the programming of Bread & Roses Presents, a nonprofit organization working in a variety of institutional environments, including prisons. It was their programming that inspired me to become a photographer, and it was with them that I first photographed art programming in prisons. Blessings and appreciation to Bread & Roses Presents.

My final appreciation is for the friends and family who have encouraged and assisted me on this project from the very beginning—Rick Newby, Liz Gans, Liz Albritton, and Larry Brewster. Thanks to you all.

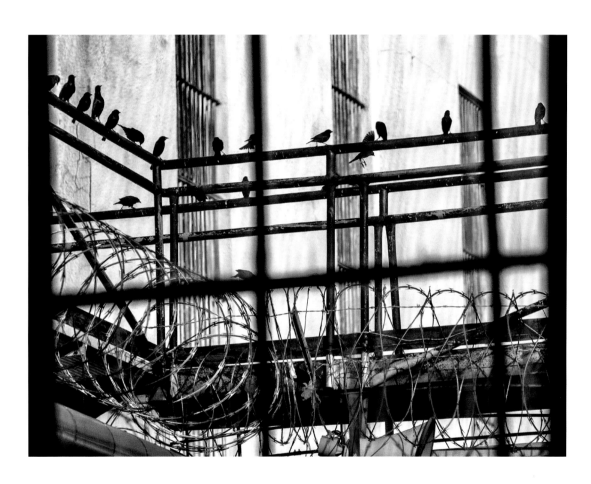

View from the art studio
San Quentin State Prison, 2006

Addendum to

Ex Crucible
The Passion of Incarcerated Artists

Prison Towns

Peter Merts

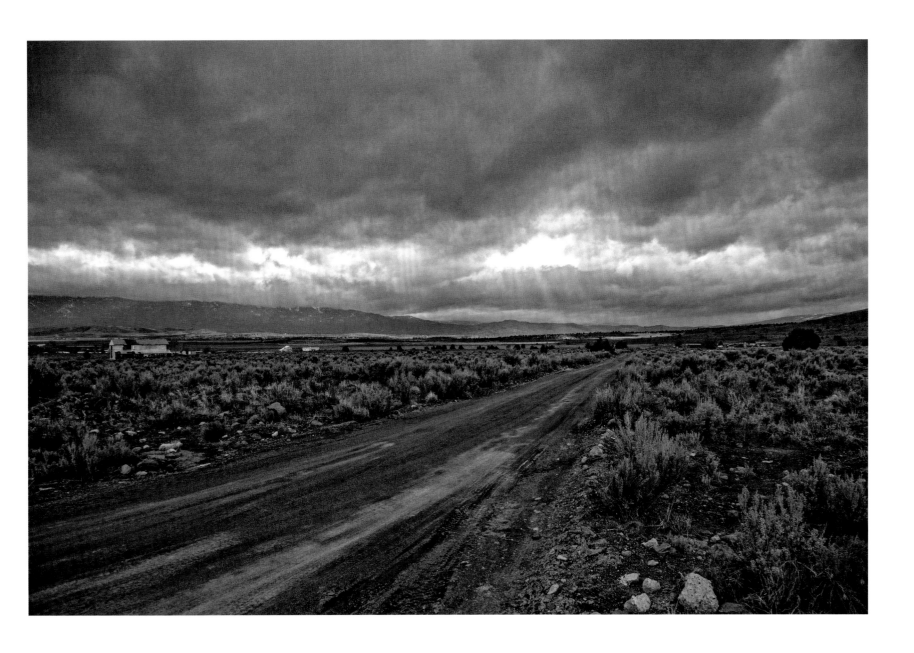

Susanville
near High Desert State Prison and California Correctional Center, 2016

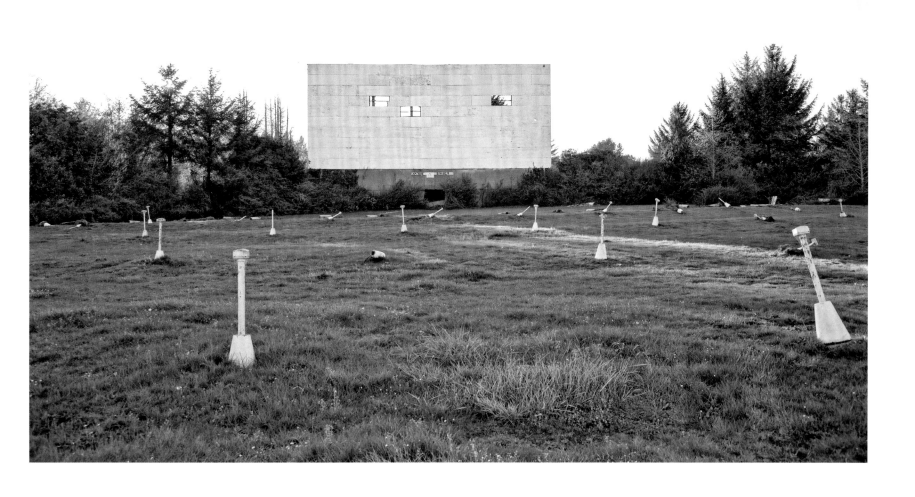

Crescent City
near Pelican Bay State Prison, 2016

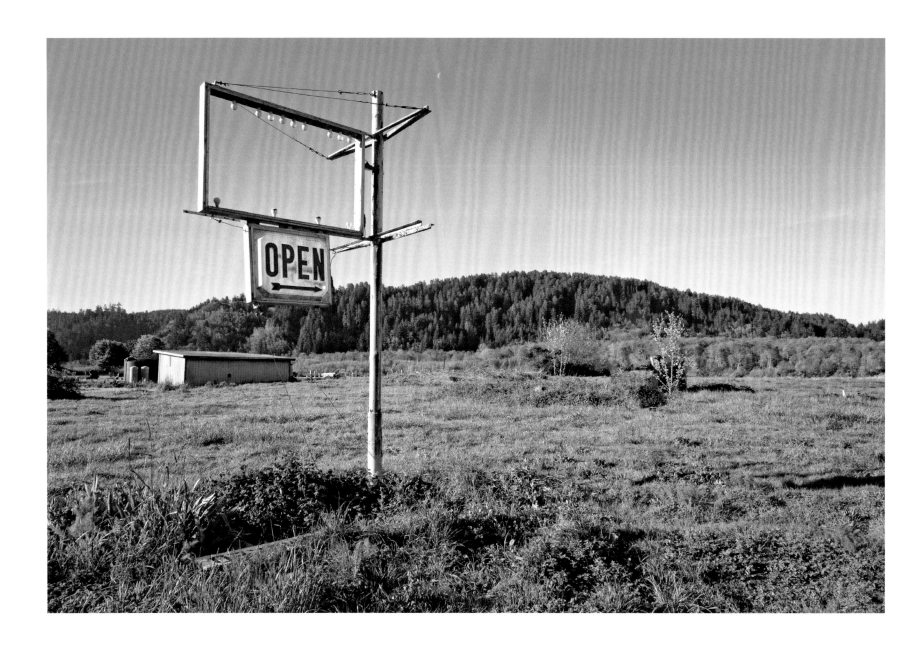

Orick
on the way to Pelican Bay State Prison, 2016

Corcoran
near Corcoran State Prison and Substance Abuse Treatment Facility, 2016

Blythe
near Ironwood and Chuckawalla Valley state prisons, 2016

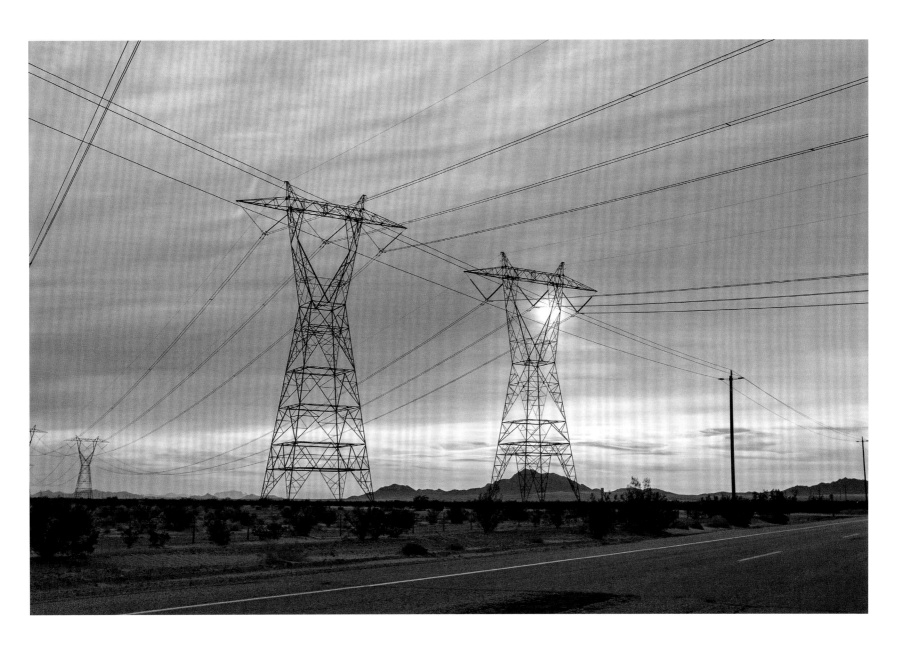

Blythe
near Ironwood and Chuckawalla Valley state prisons, 2016

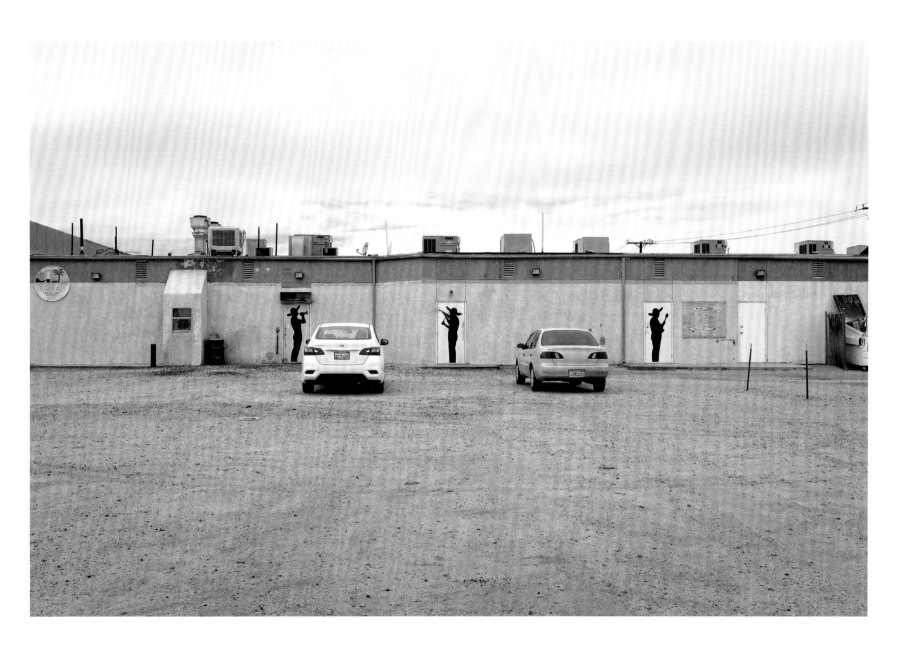

California City
near California City Correctional Facility, 2018

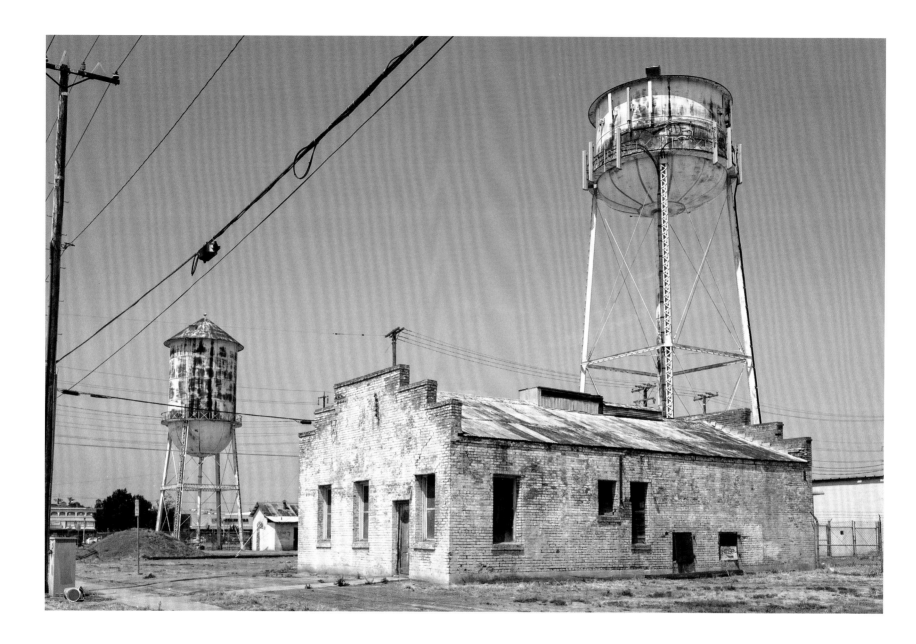

Hanford
near Corcoran State Prison and Substance Abuse Treatment Facility, 2017

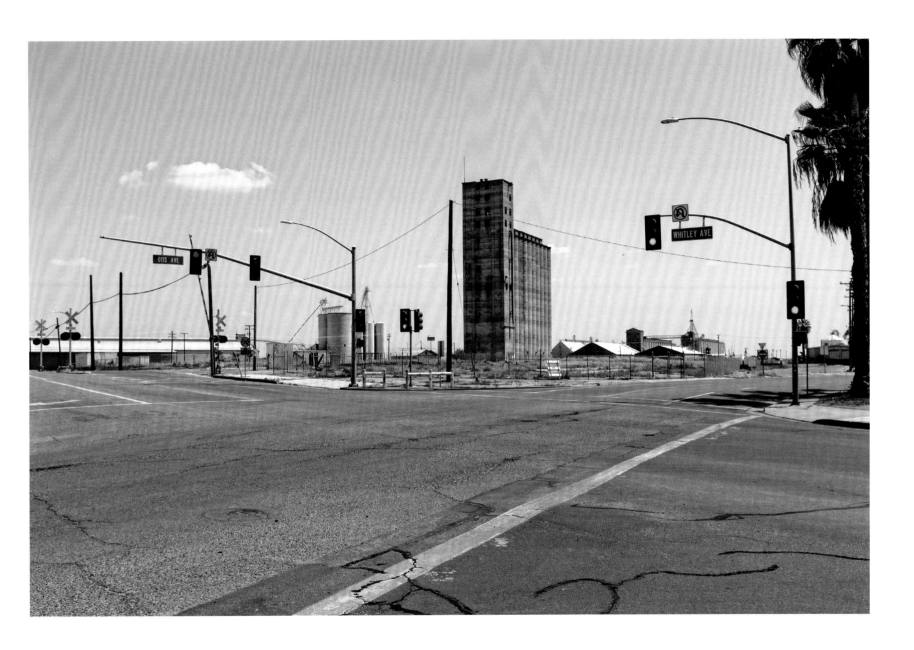

Corcoran
near Corcoran State Prison and Substance Abuse Treatment Facility, 2017

Delano
near Kern Valley and North Kern state prisons, 2018

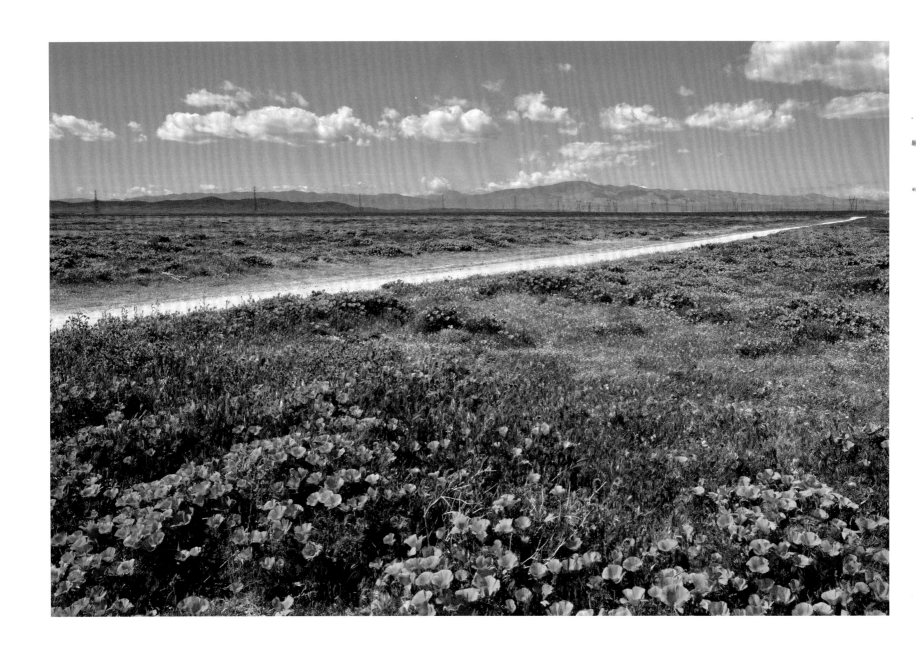

Antelope Valley
near Lancaster State Prison, 2019